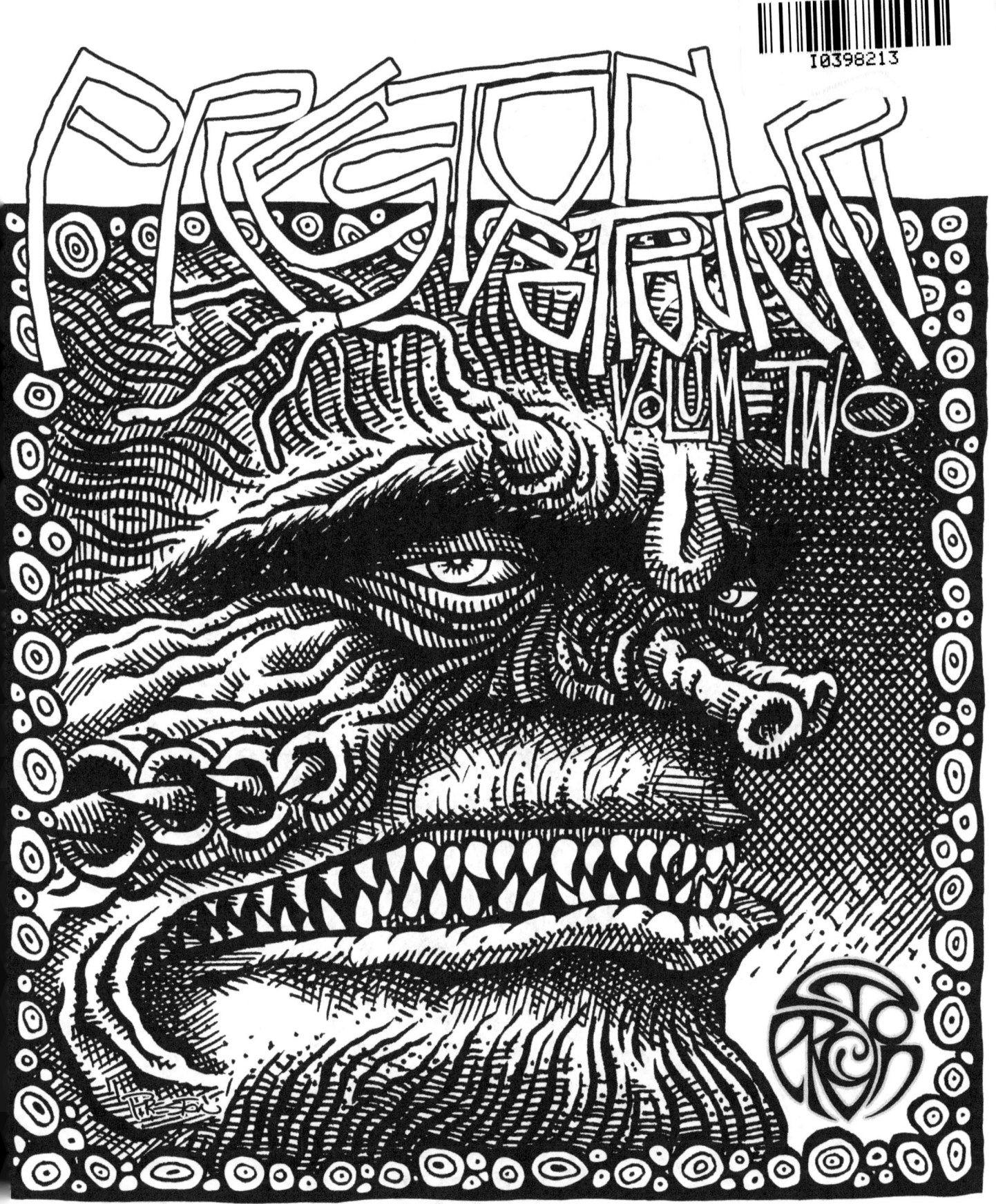

Copyright © 2017 by Dennis Preston
All rights reserved

ISBN 978-1-365-97088-7

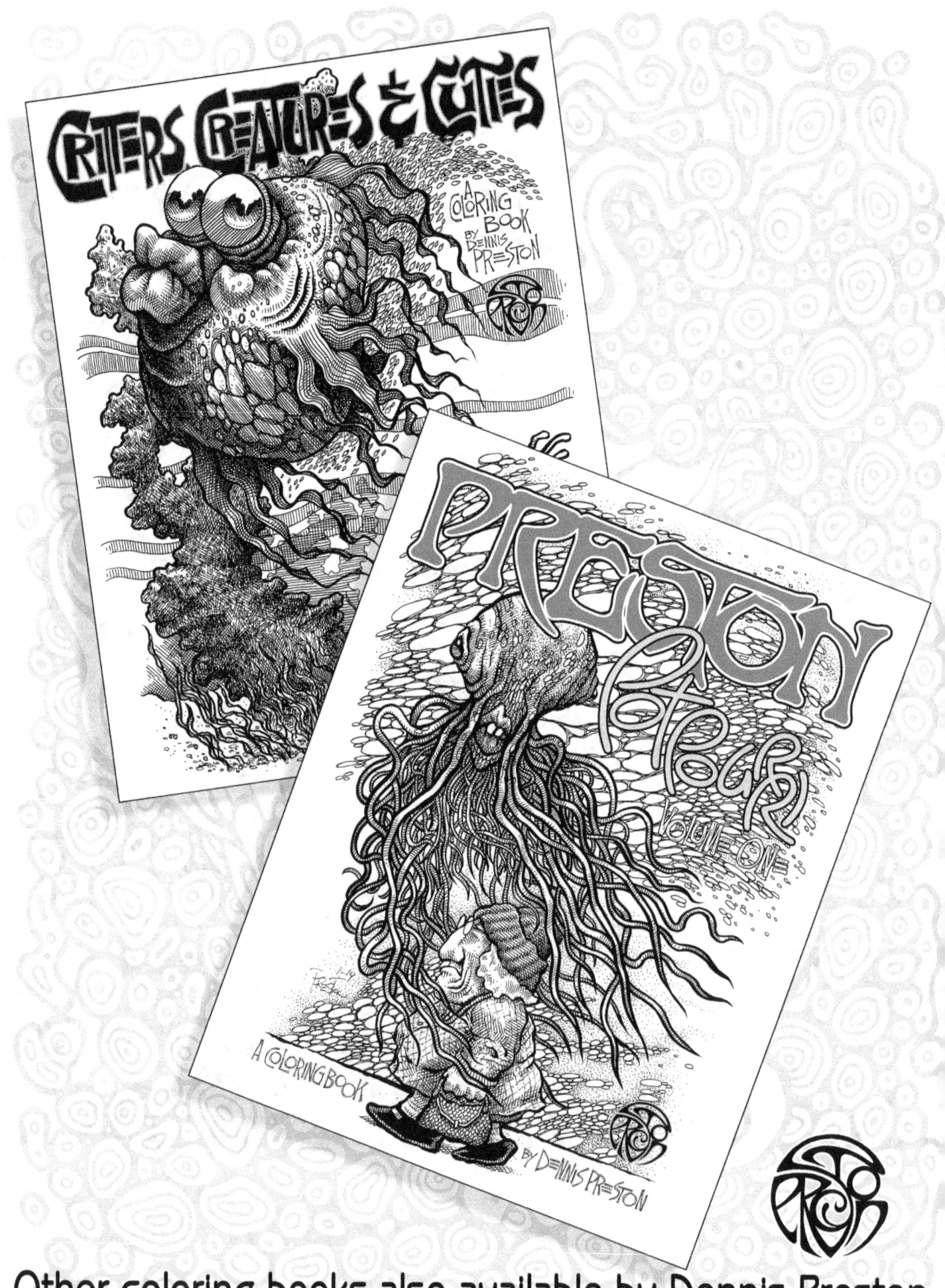

Other coloring books also available by Dennis Preston.

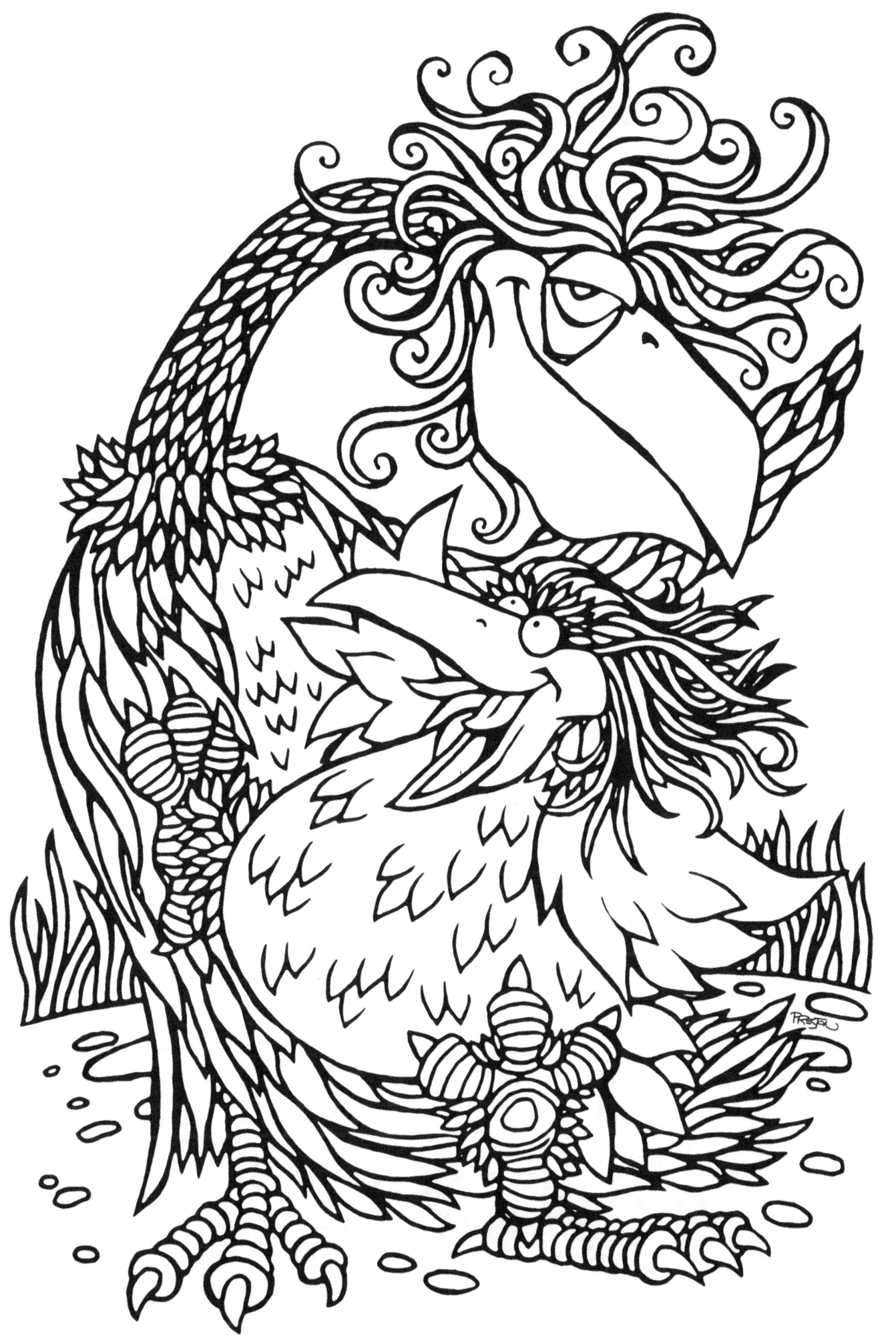

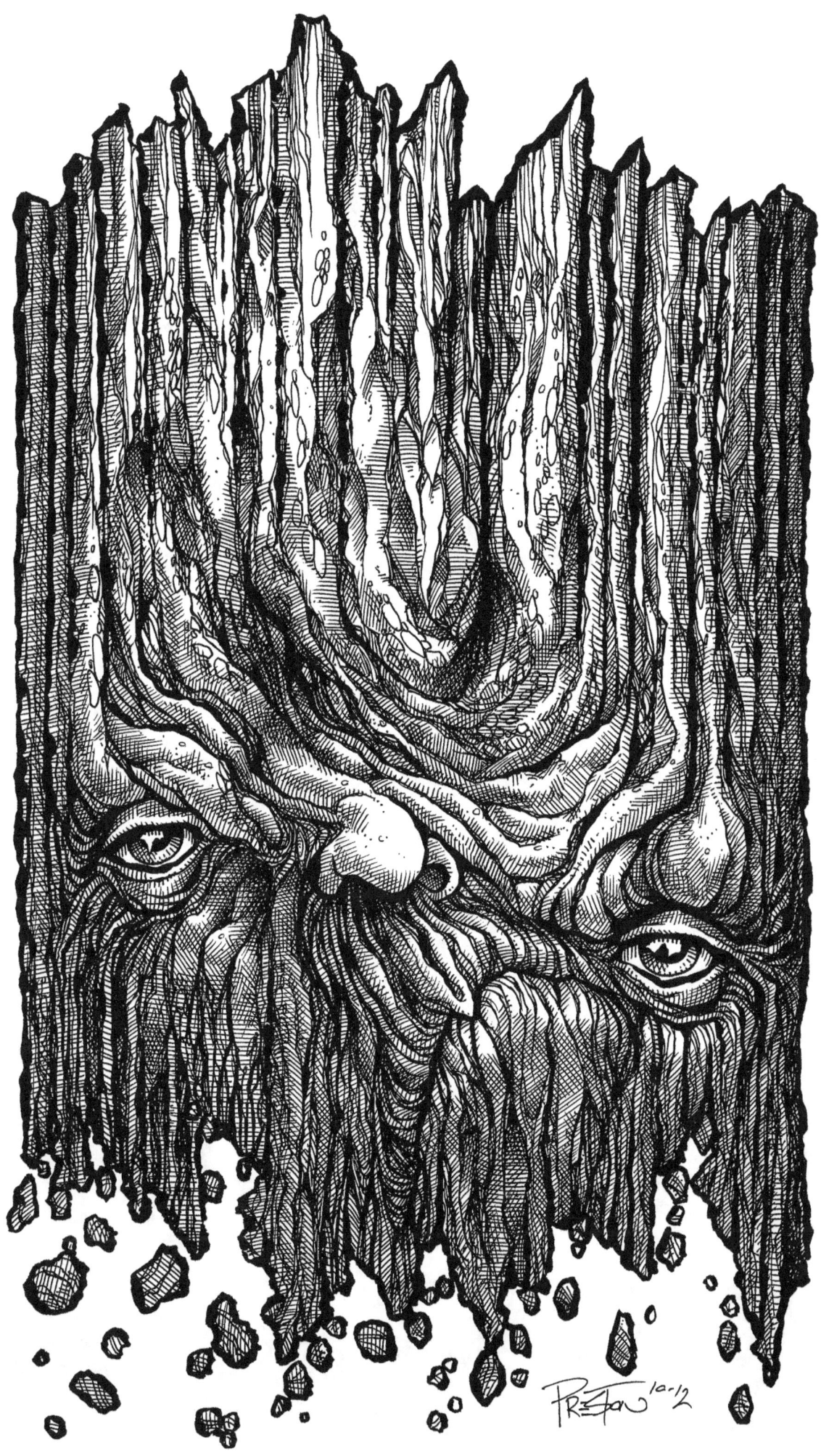

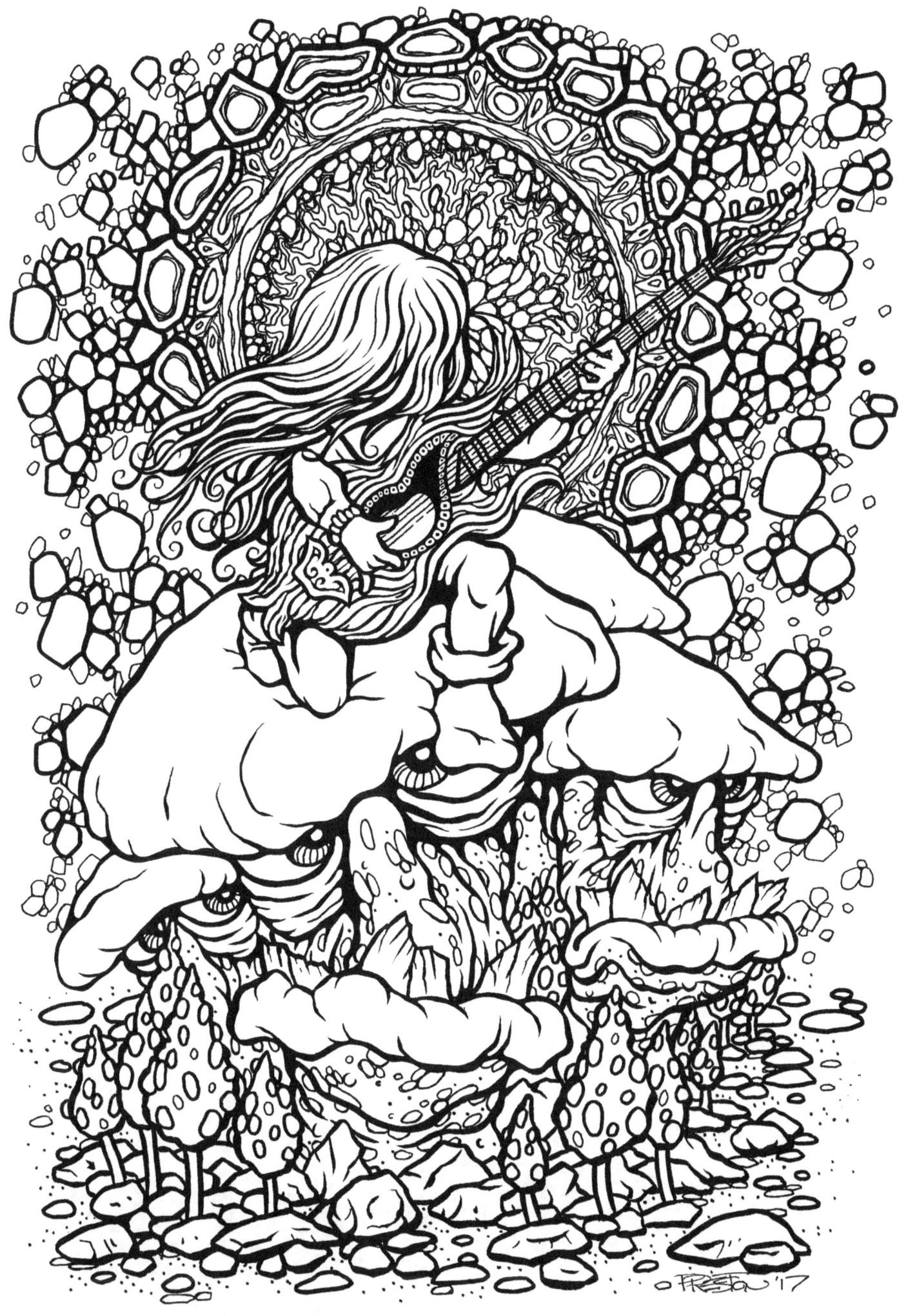

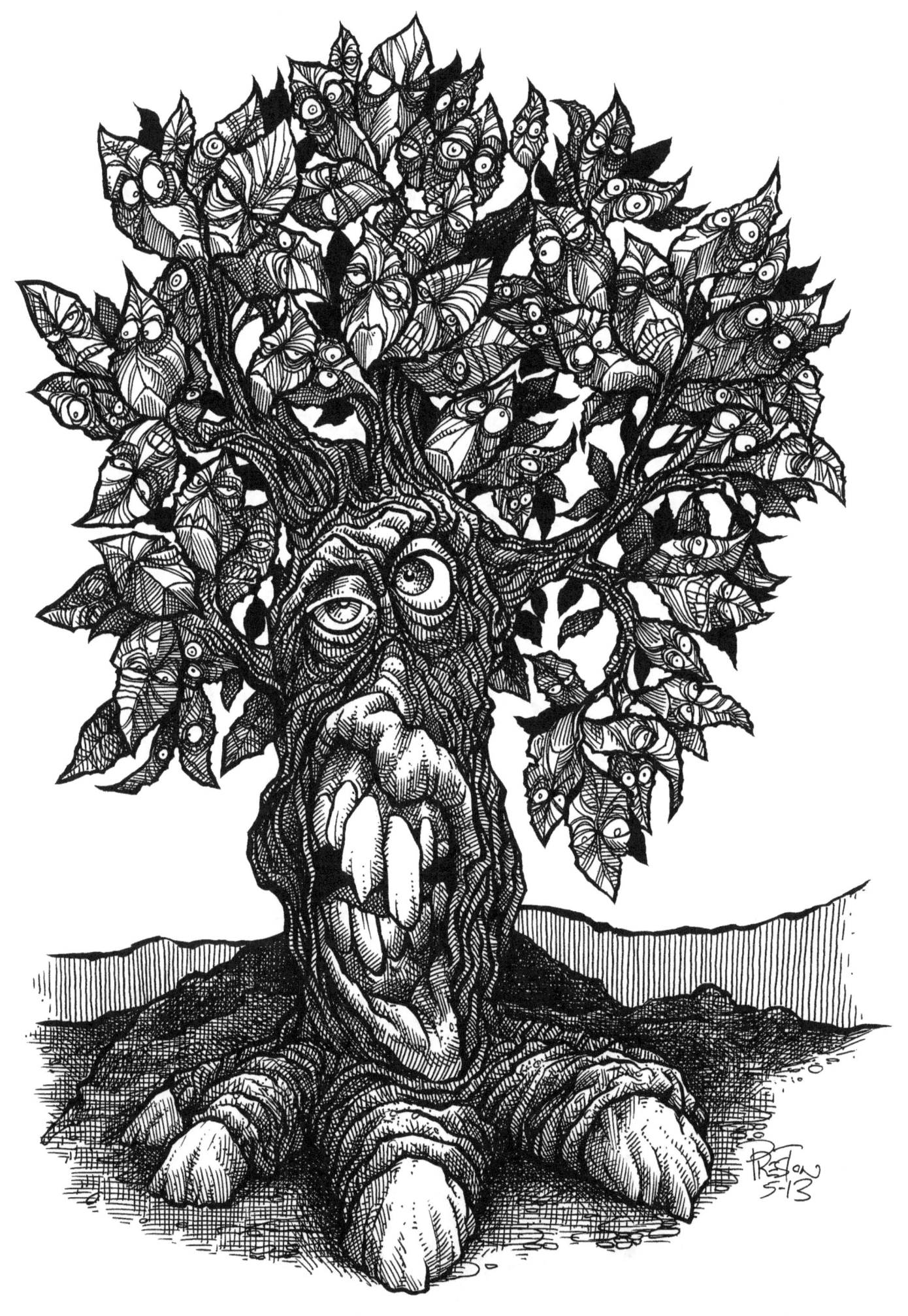

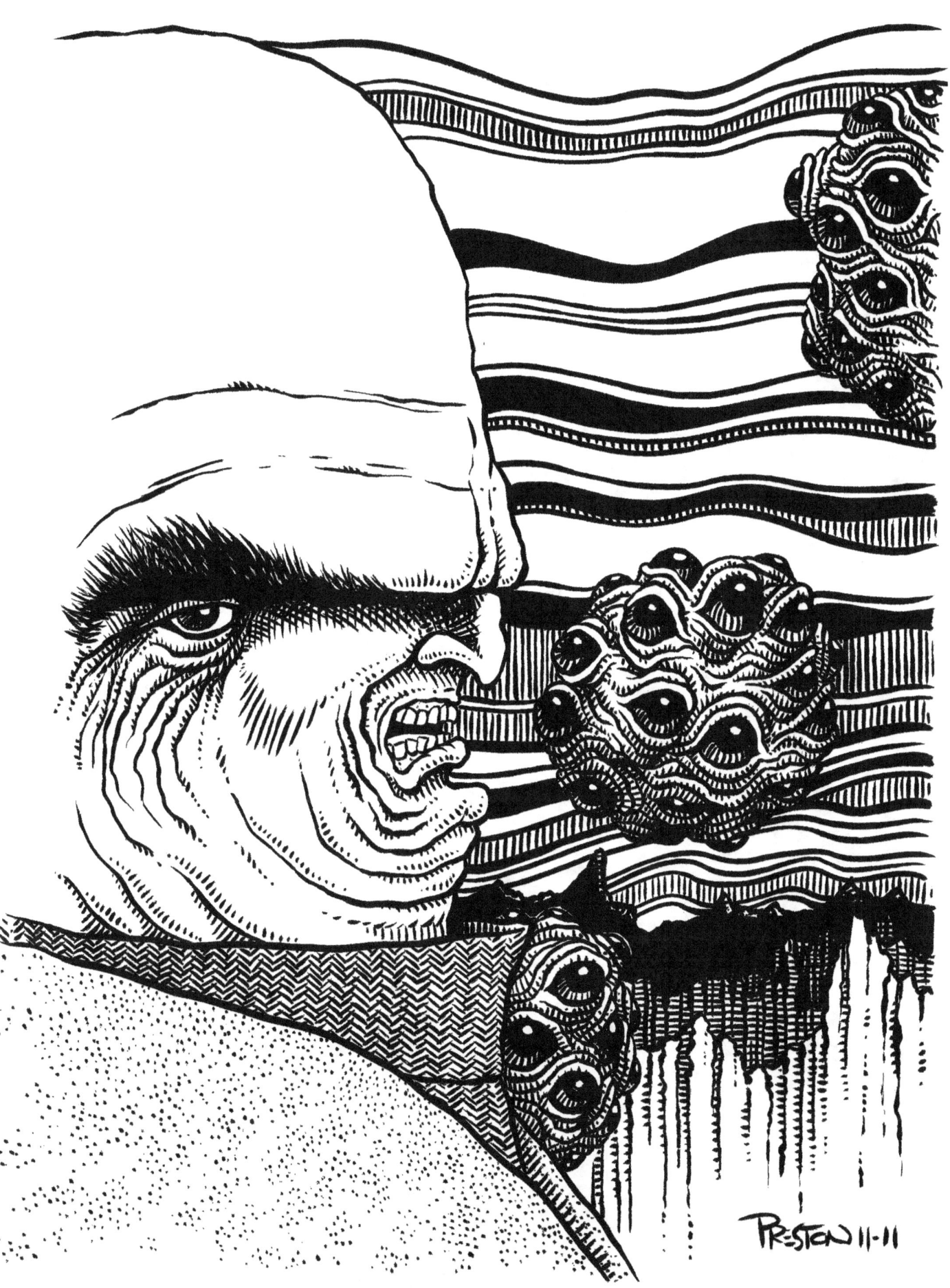

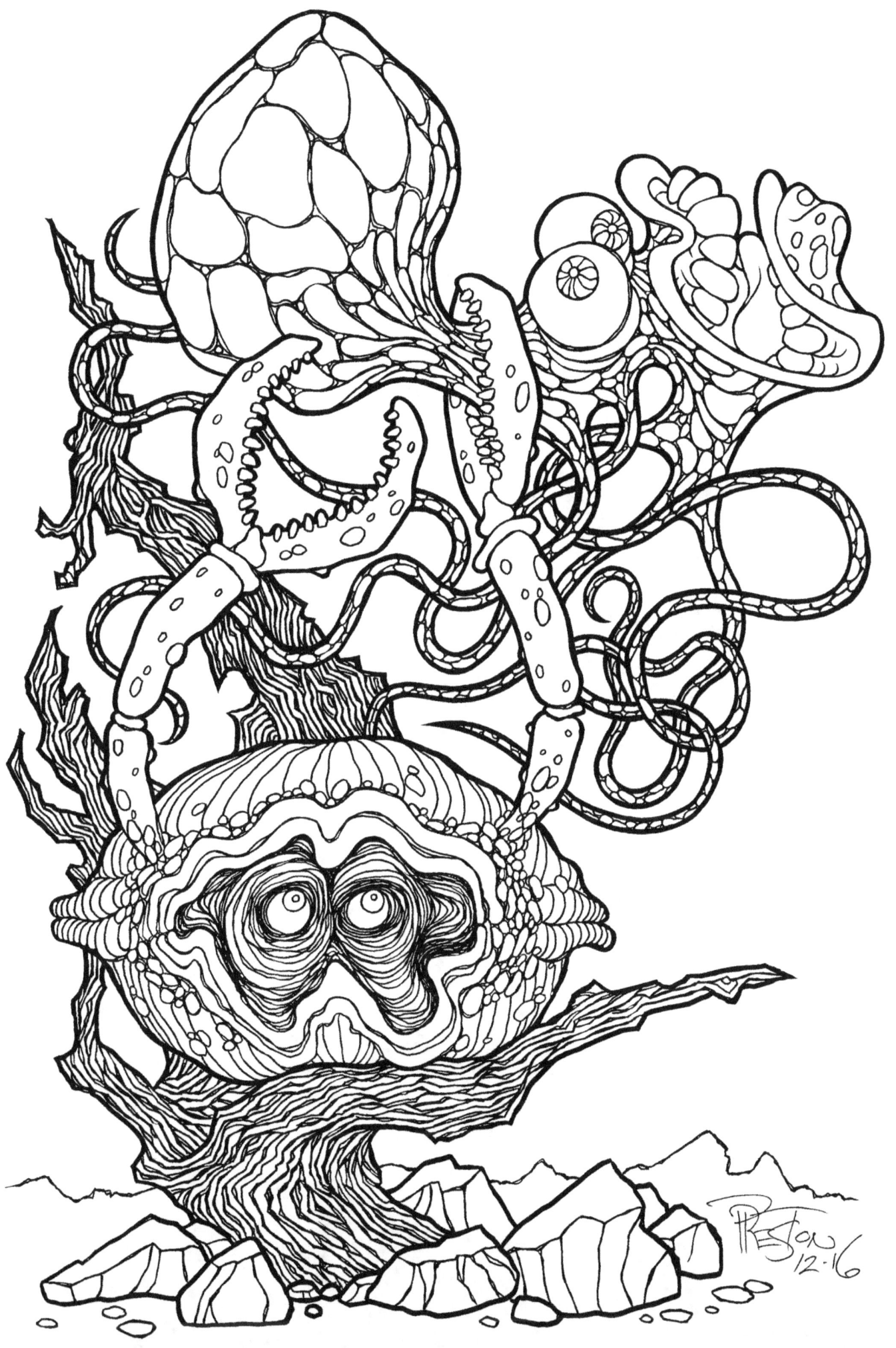

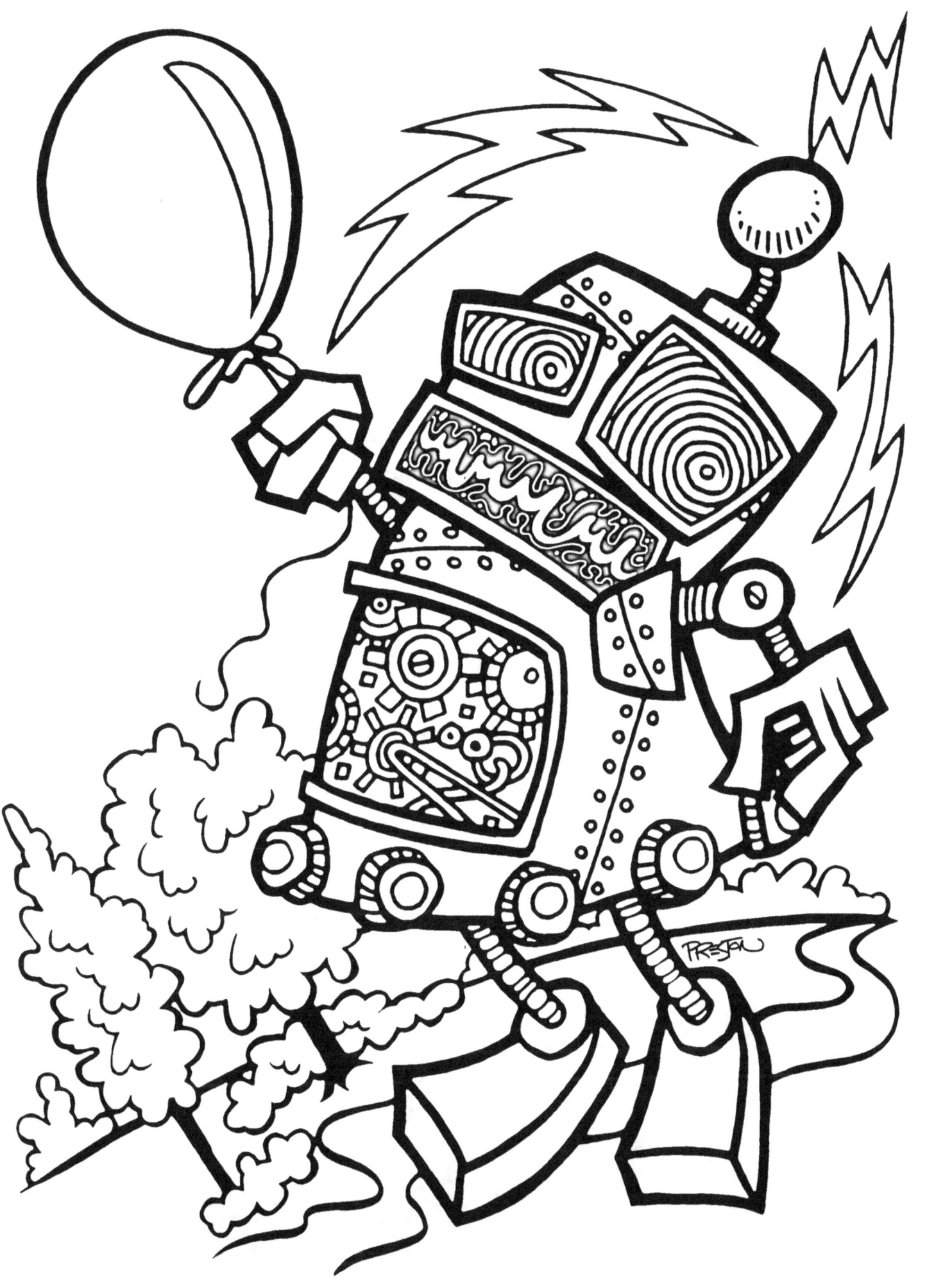

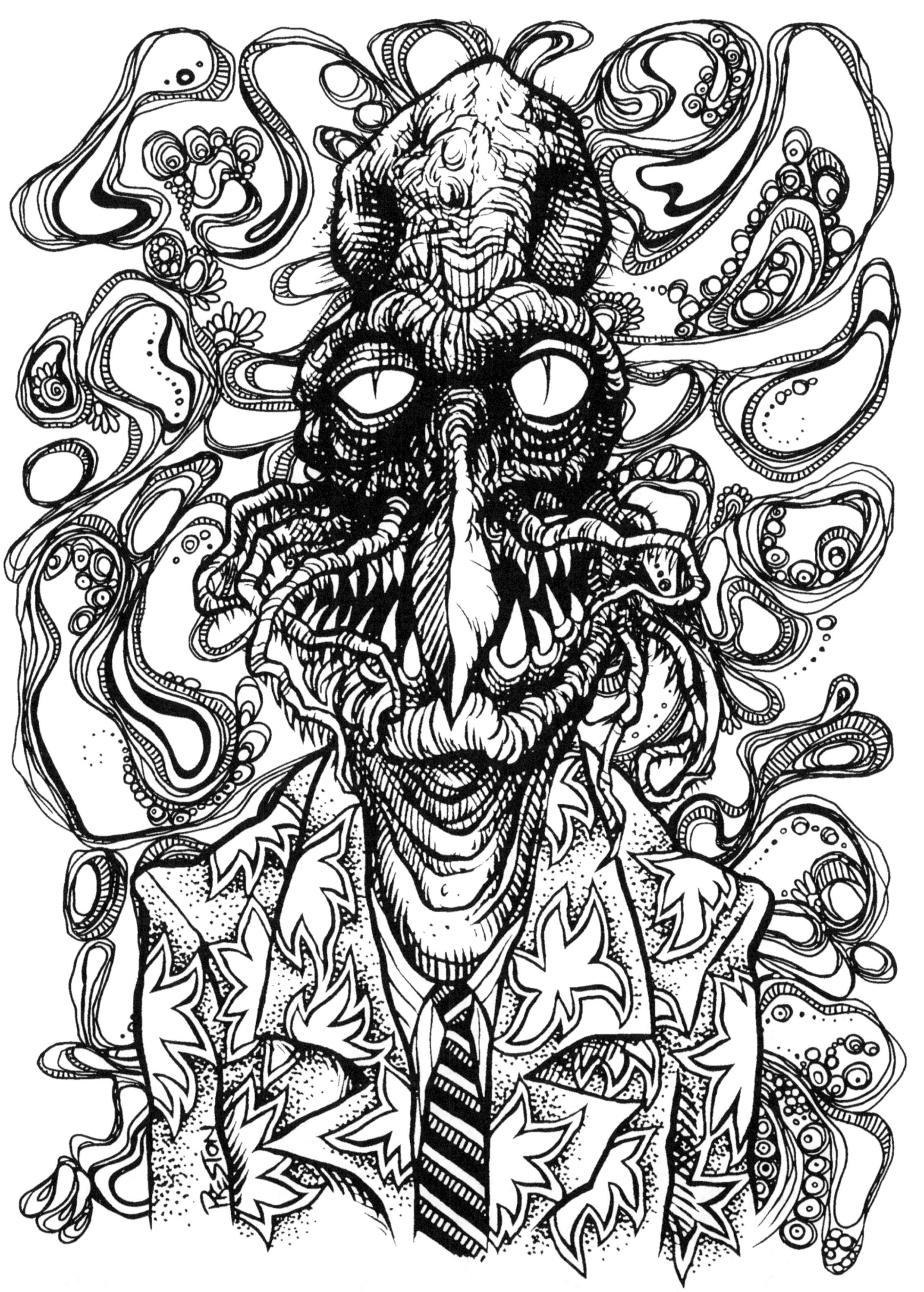

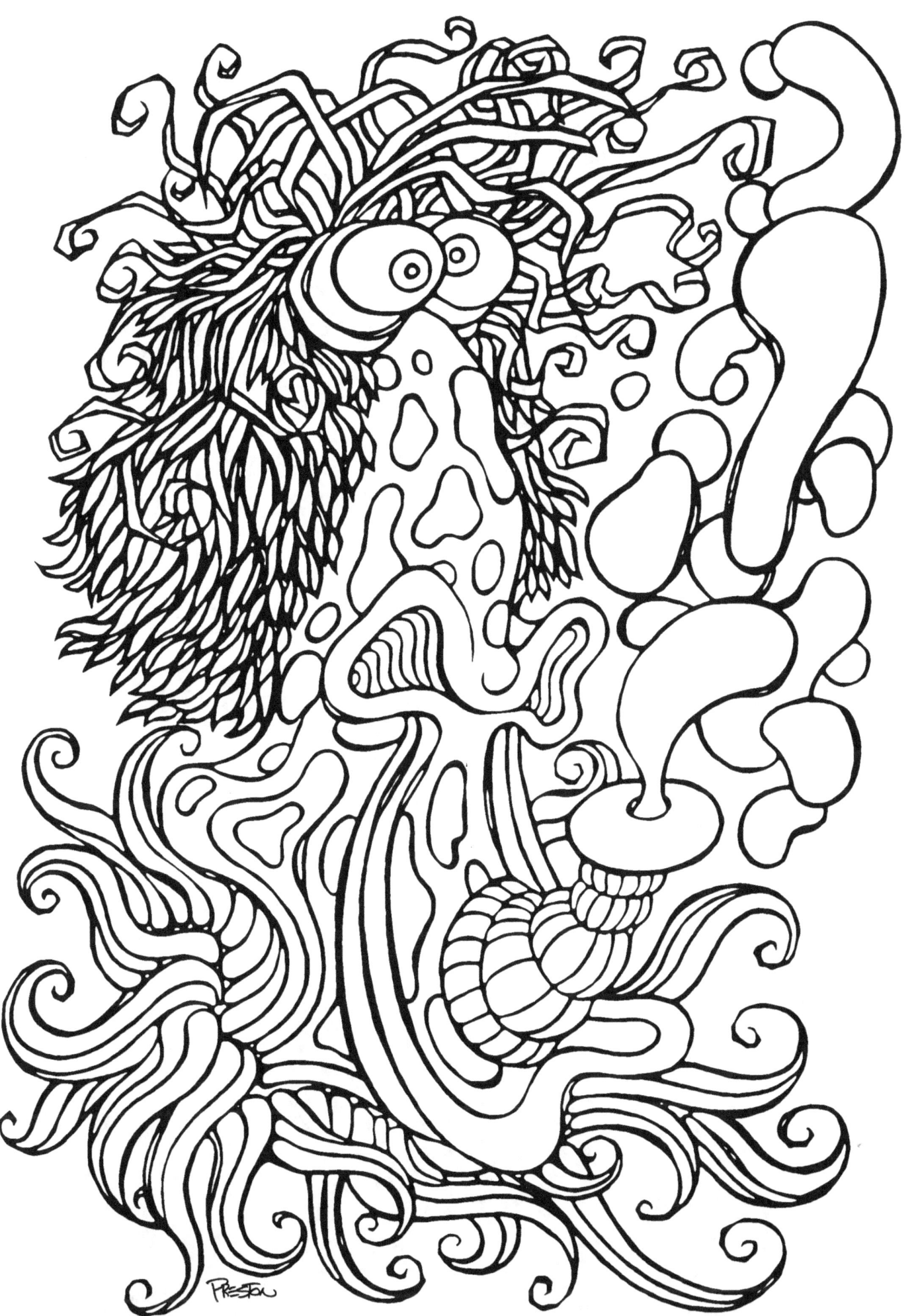

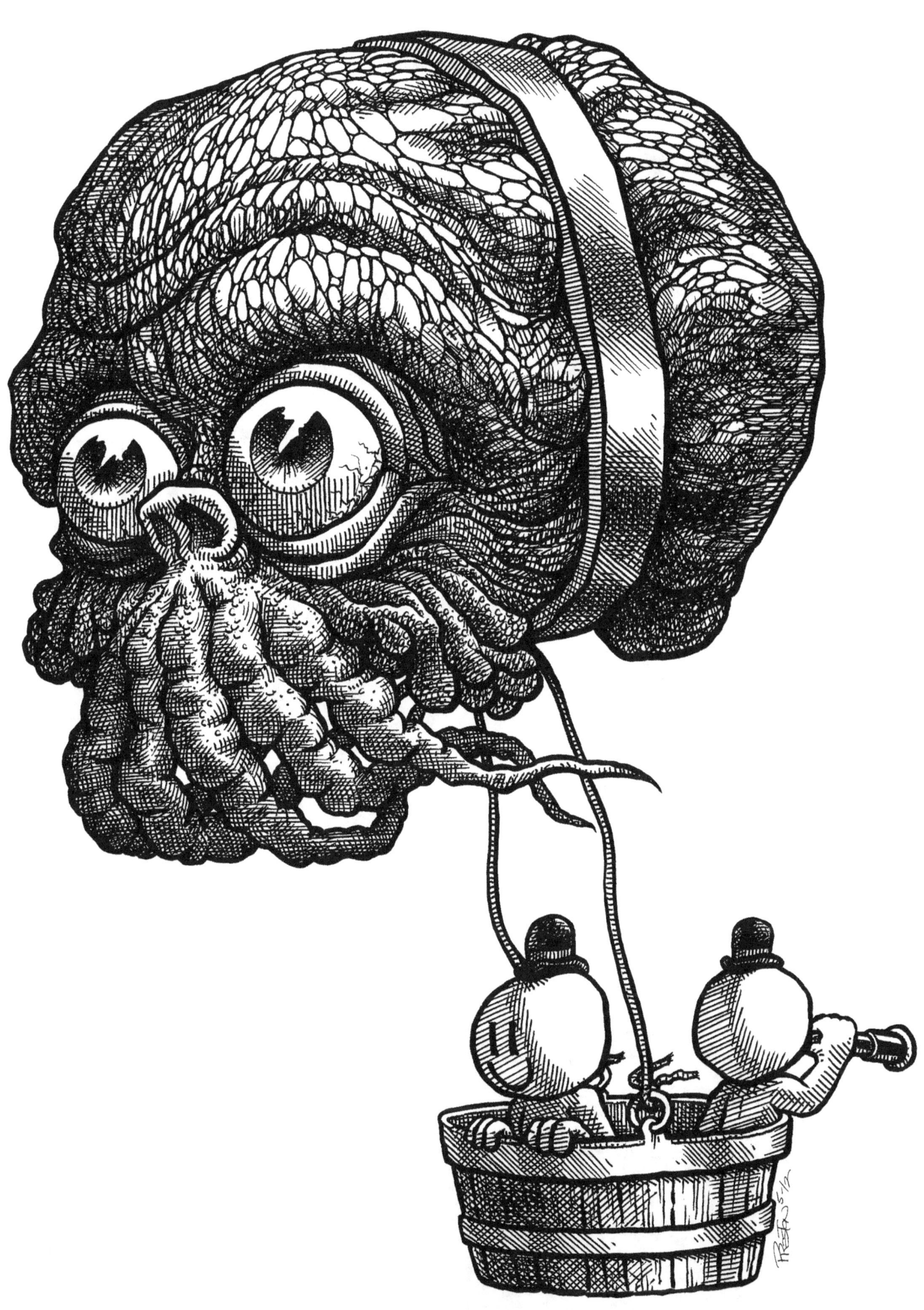

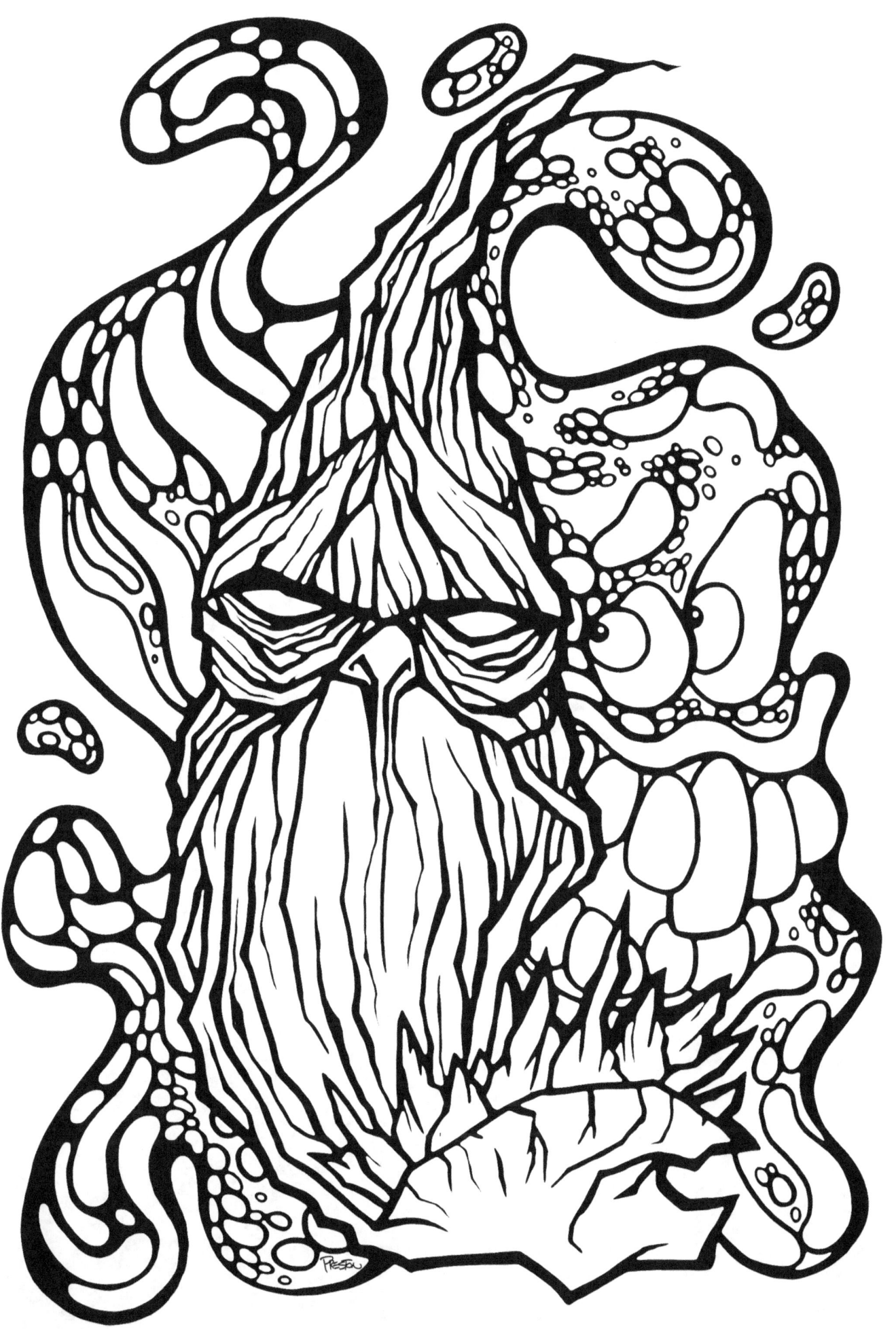

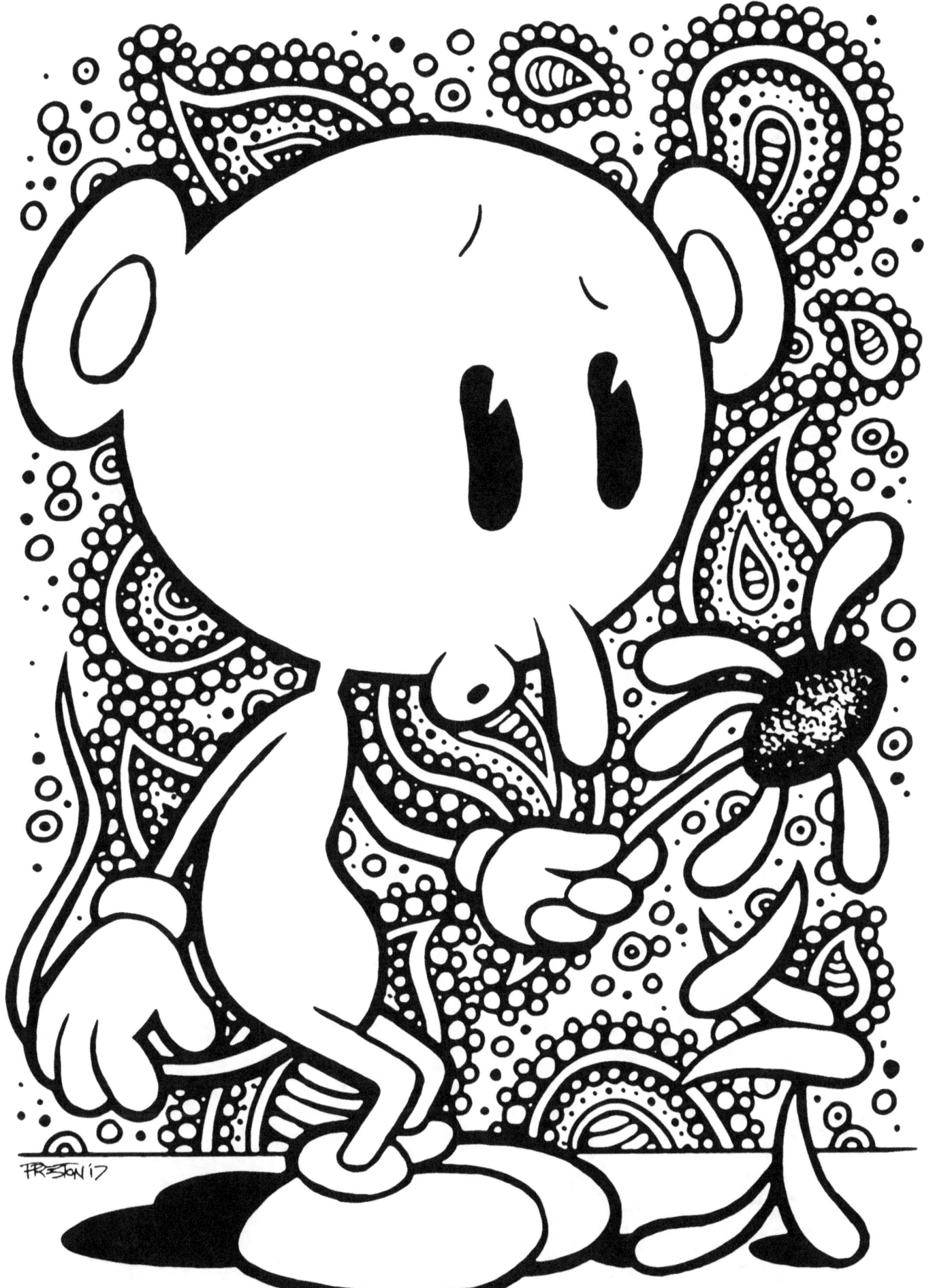

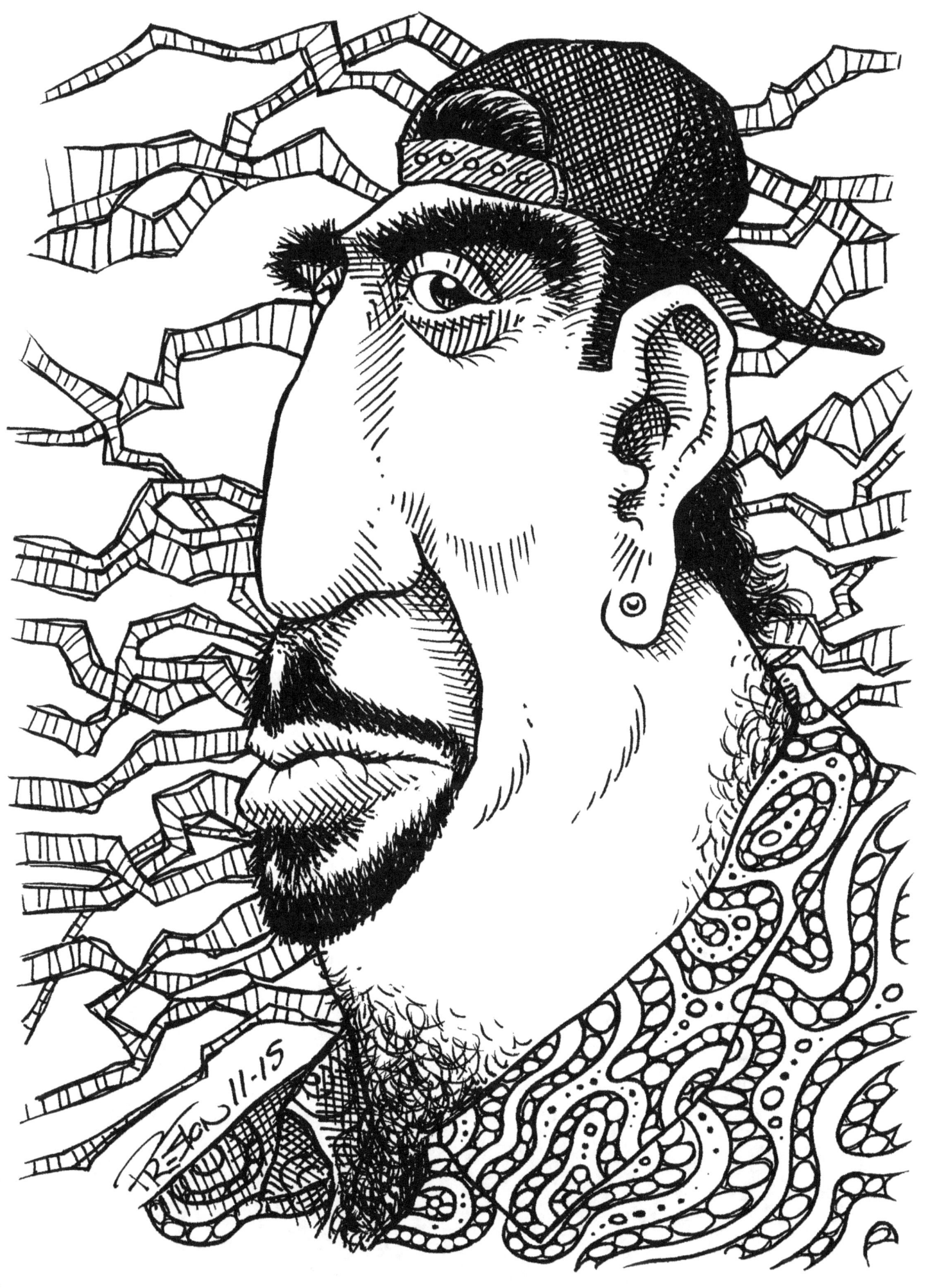

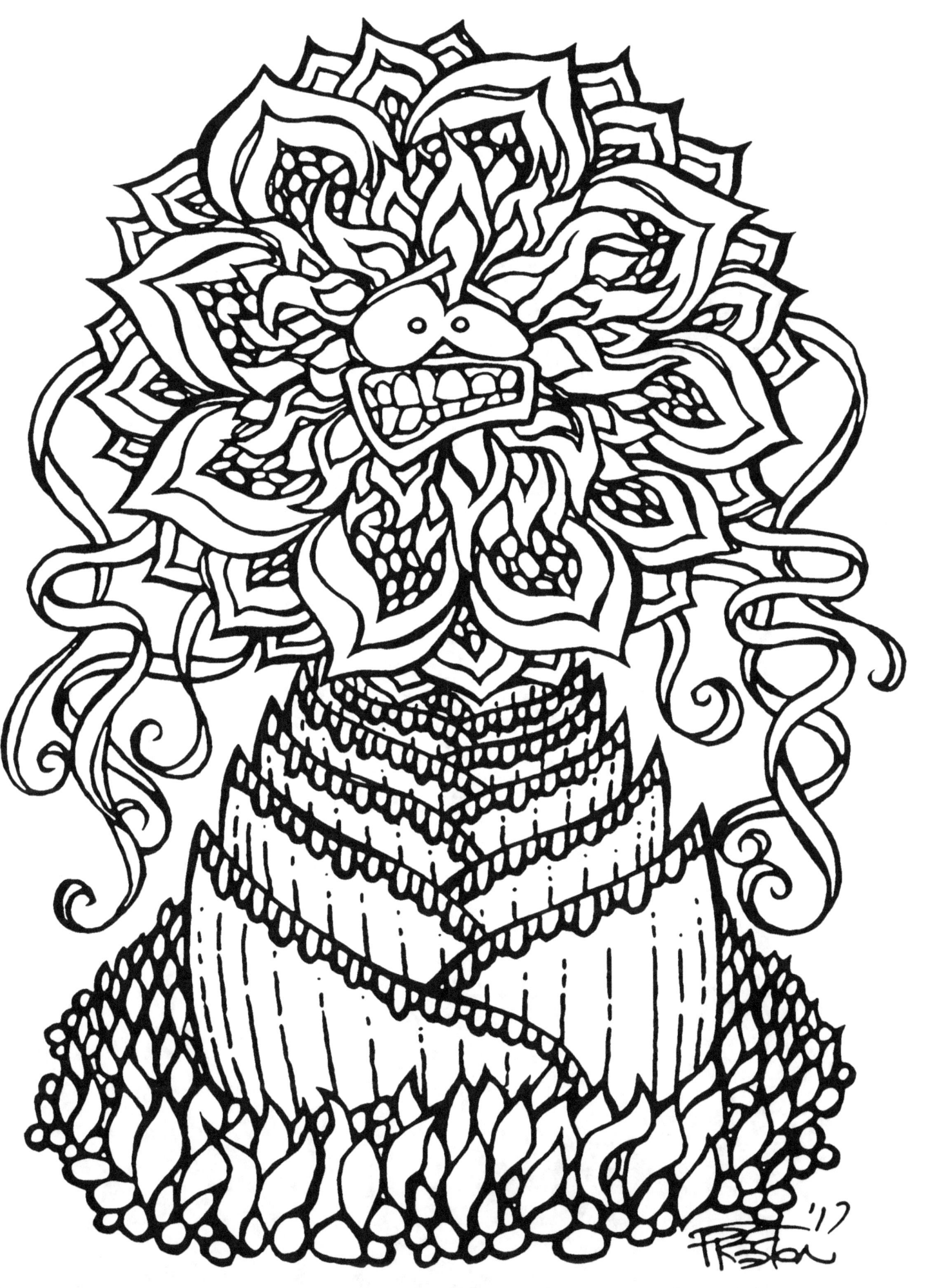

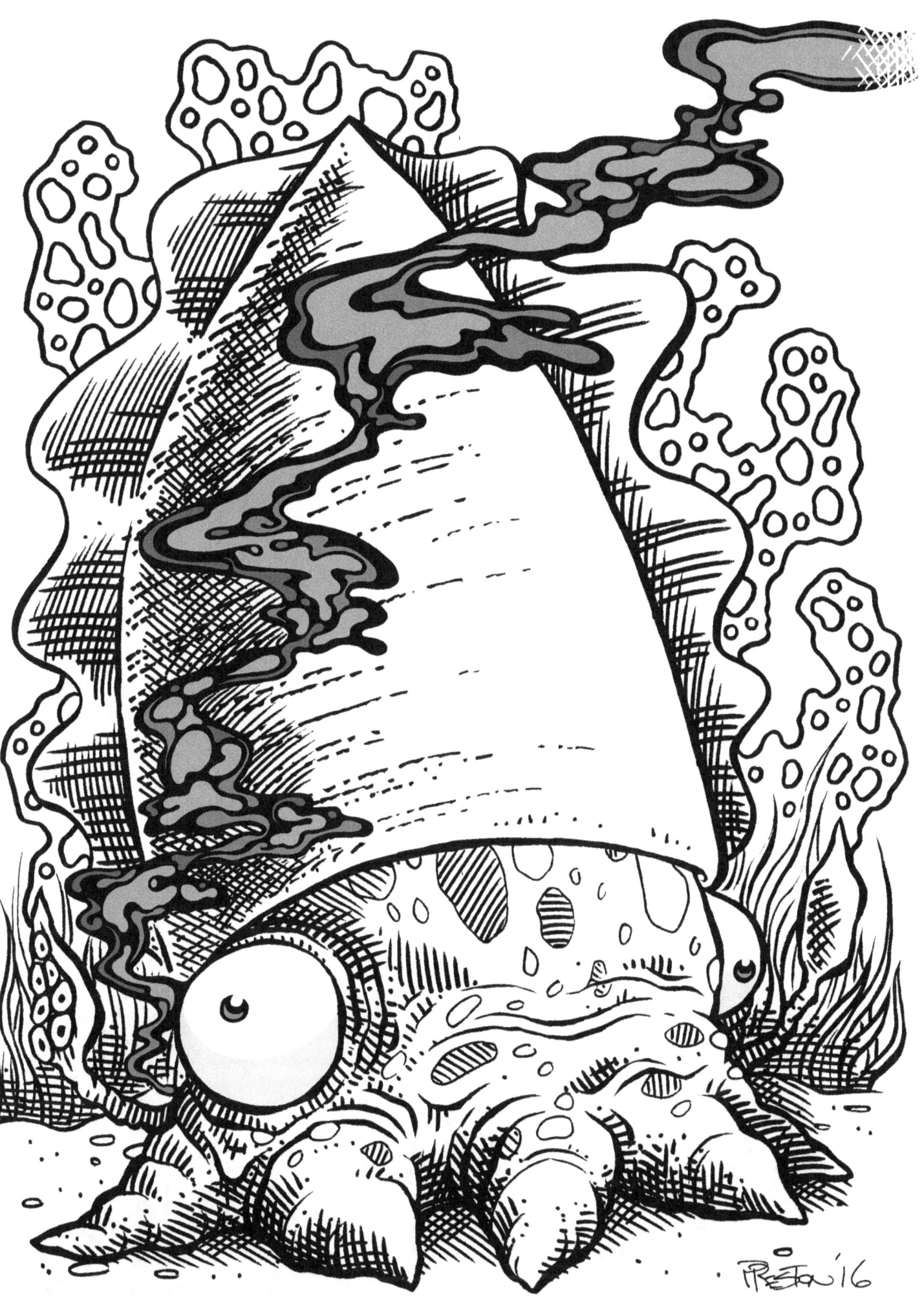

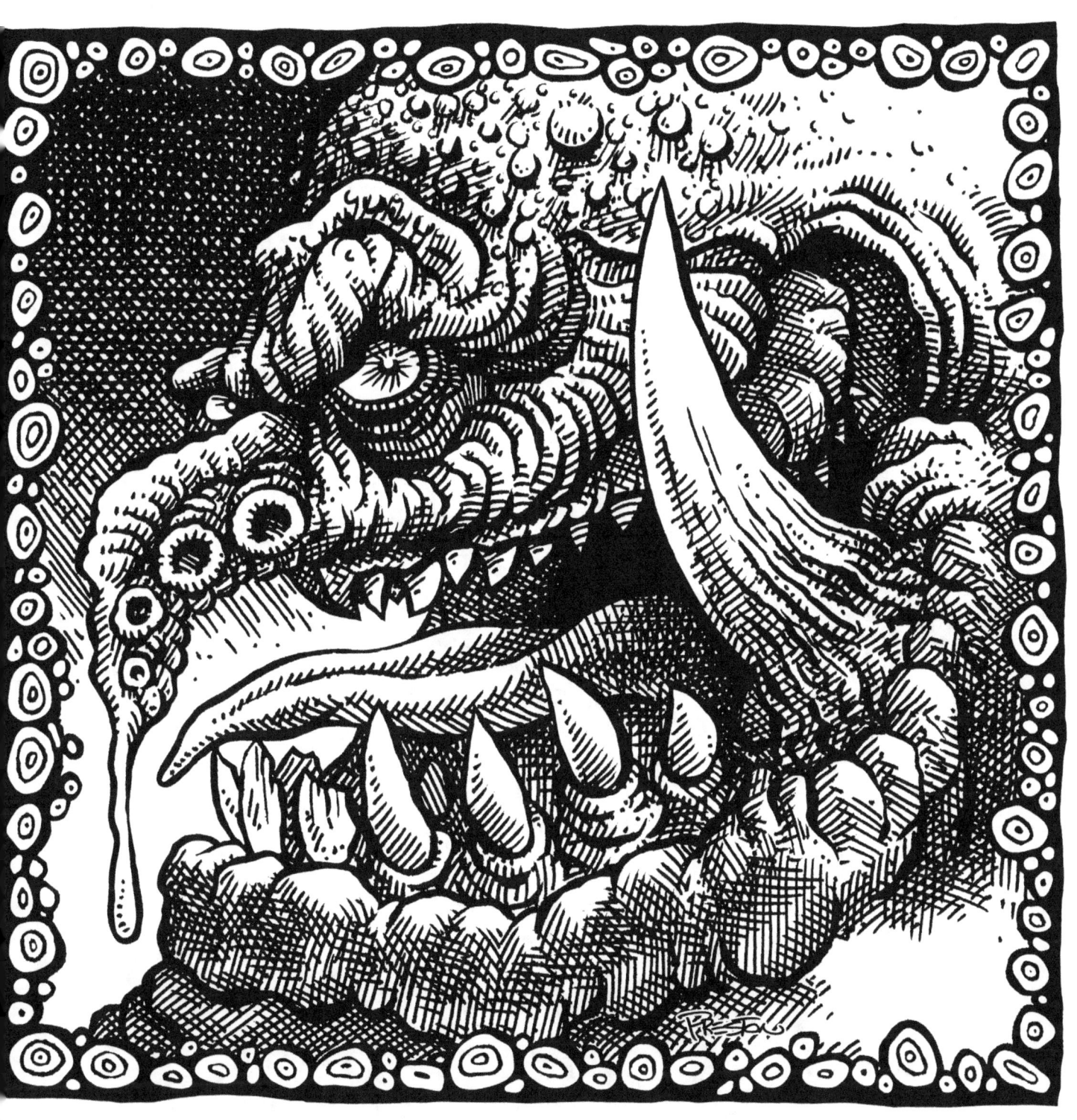

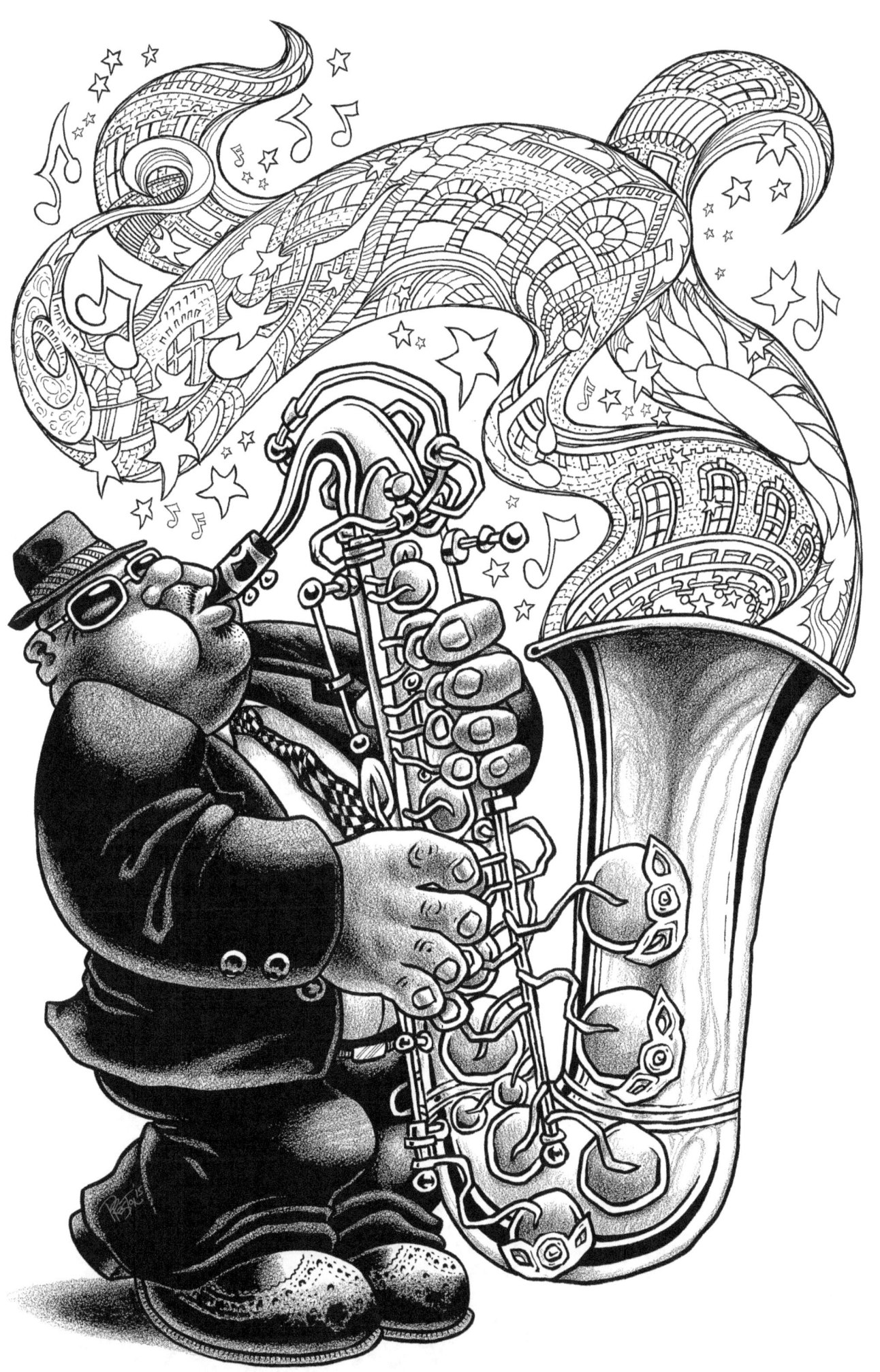

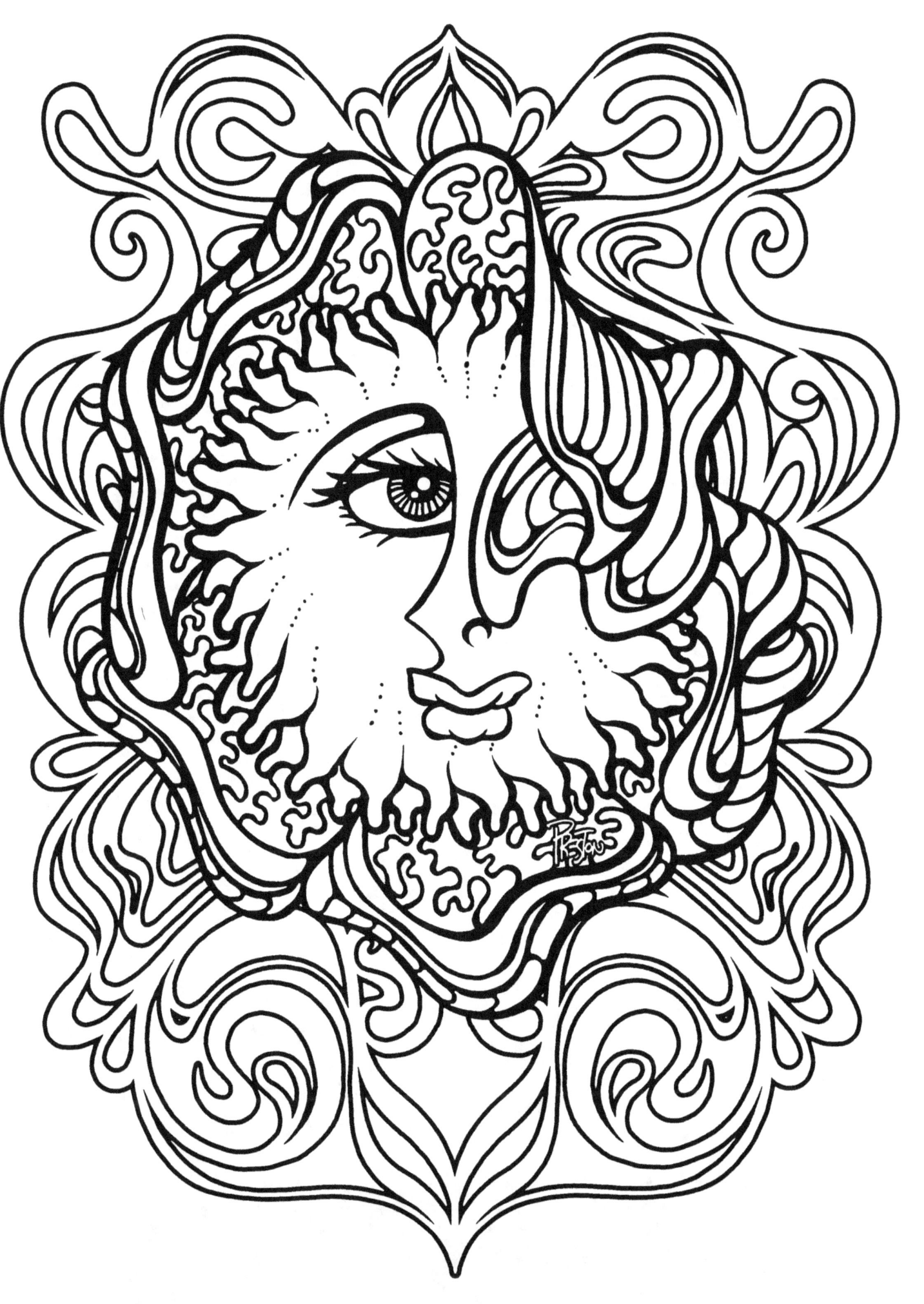

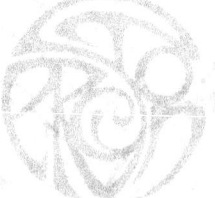

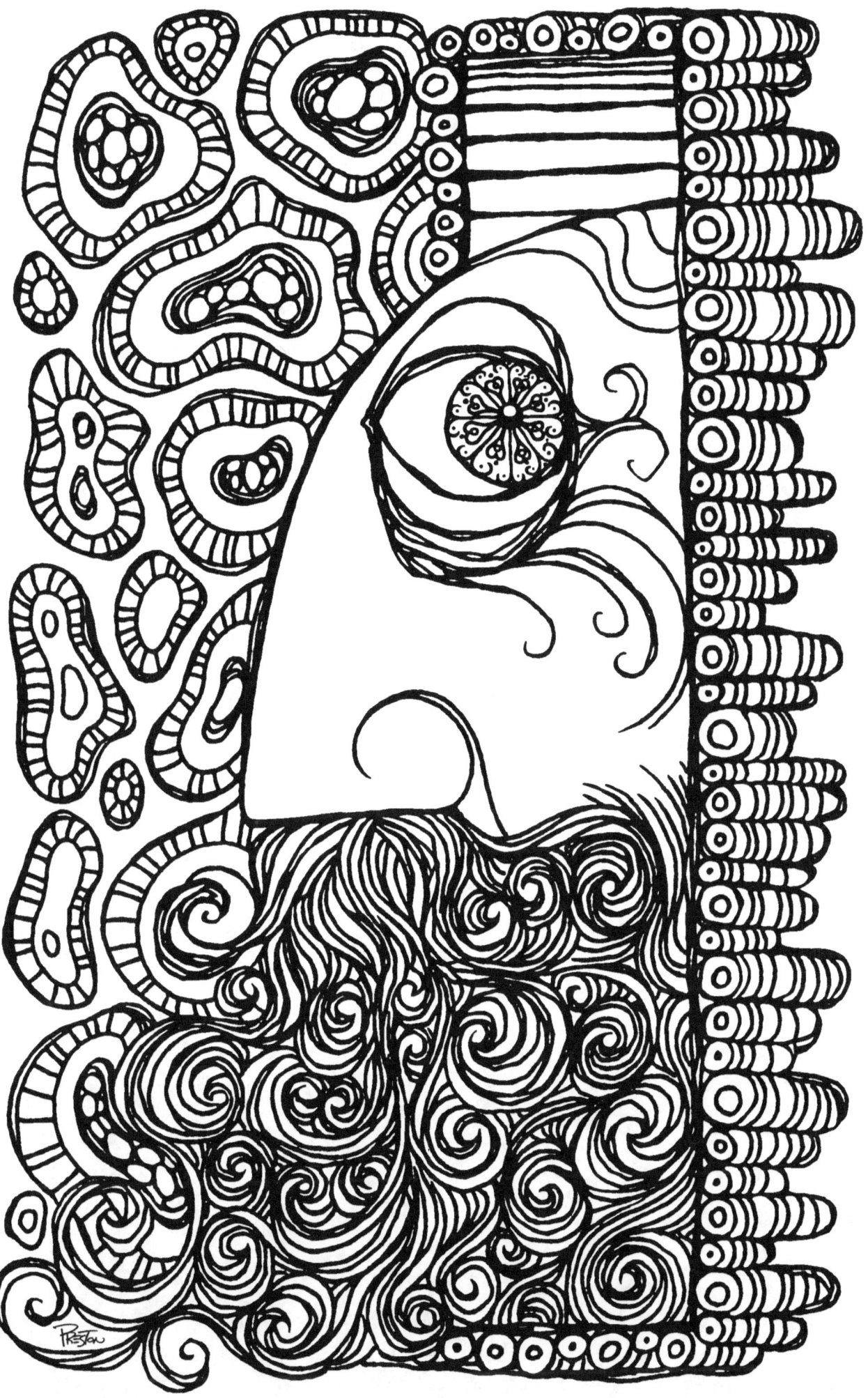

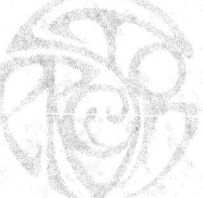

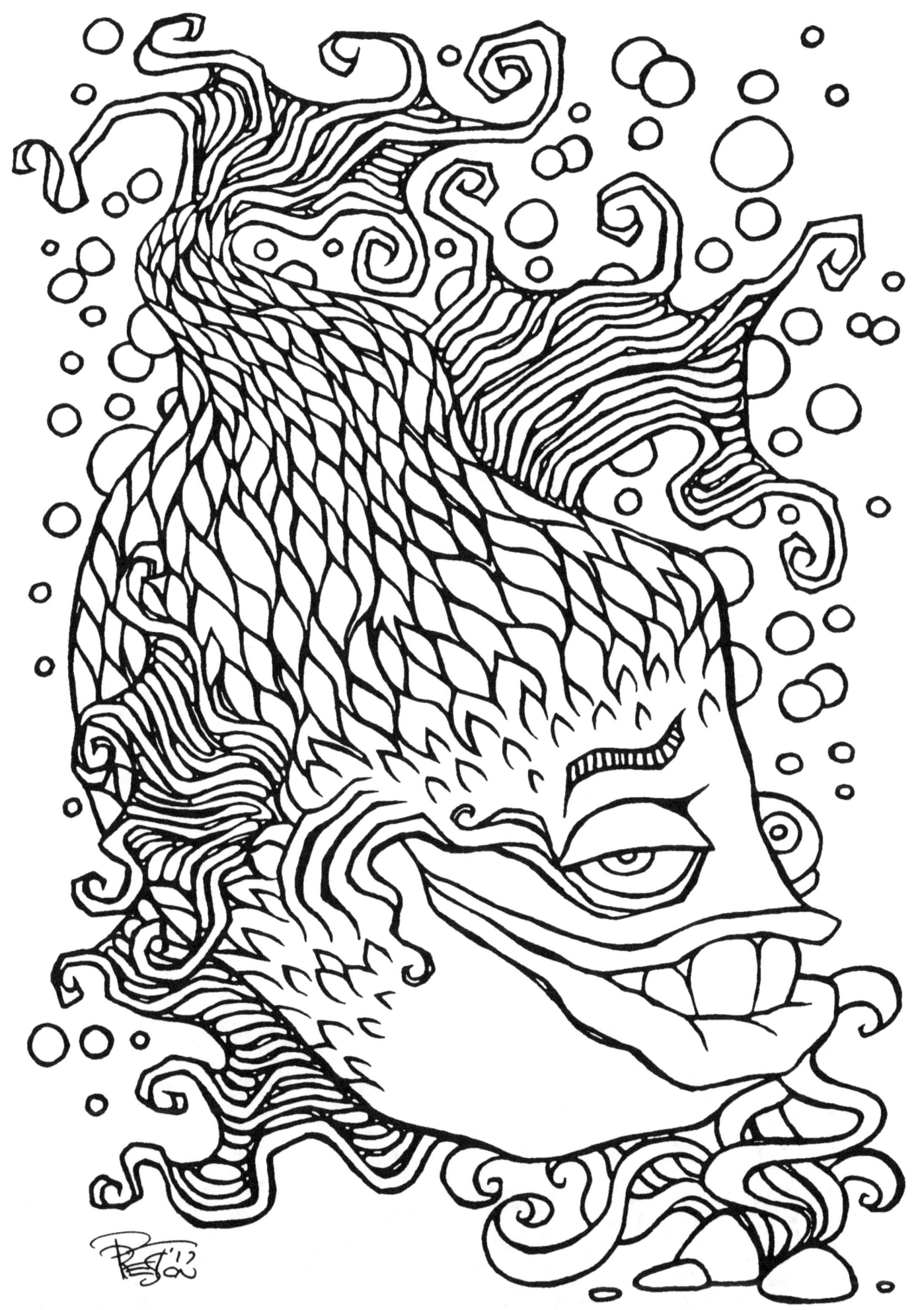

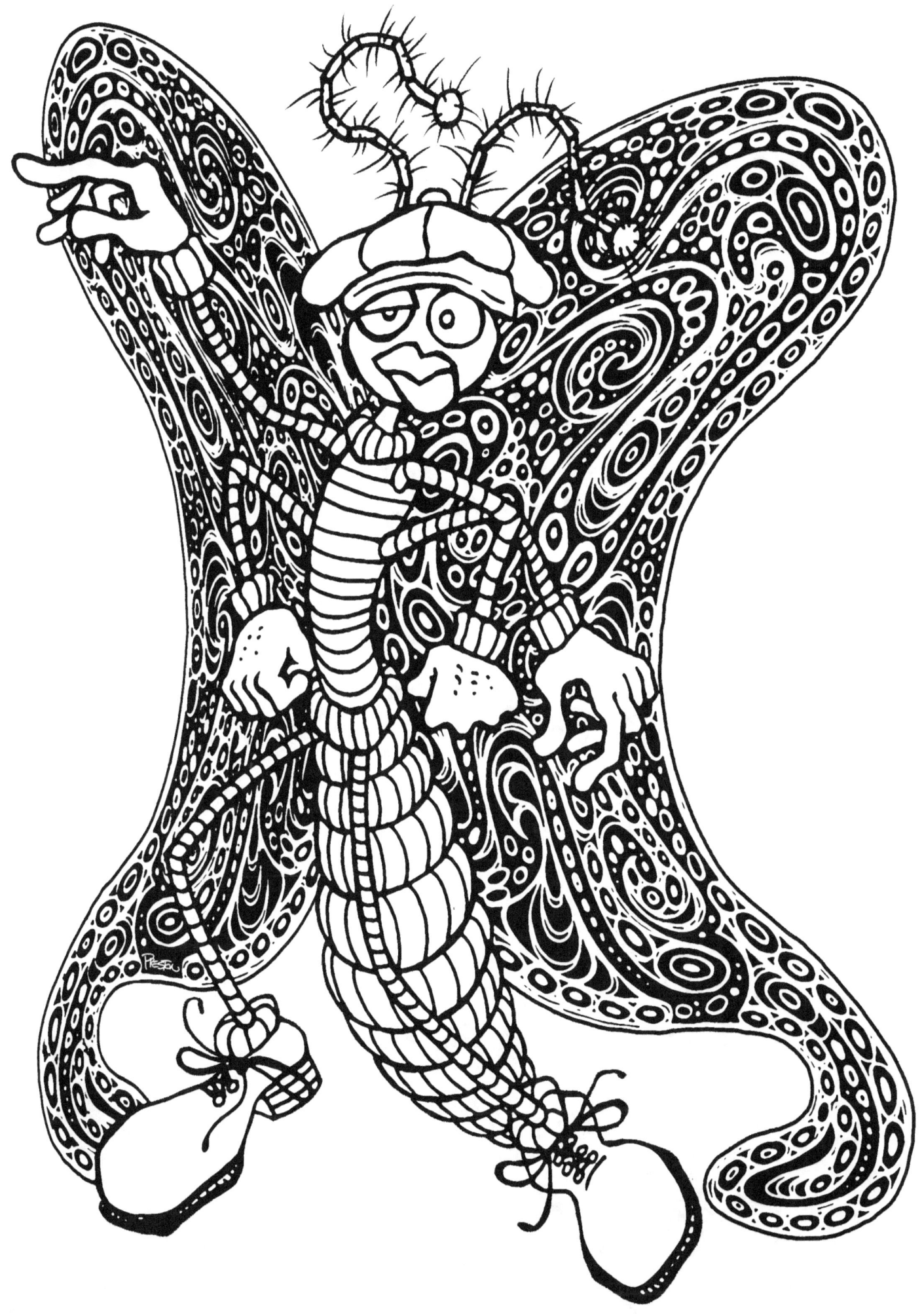

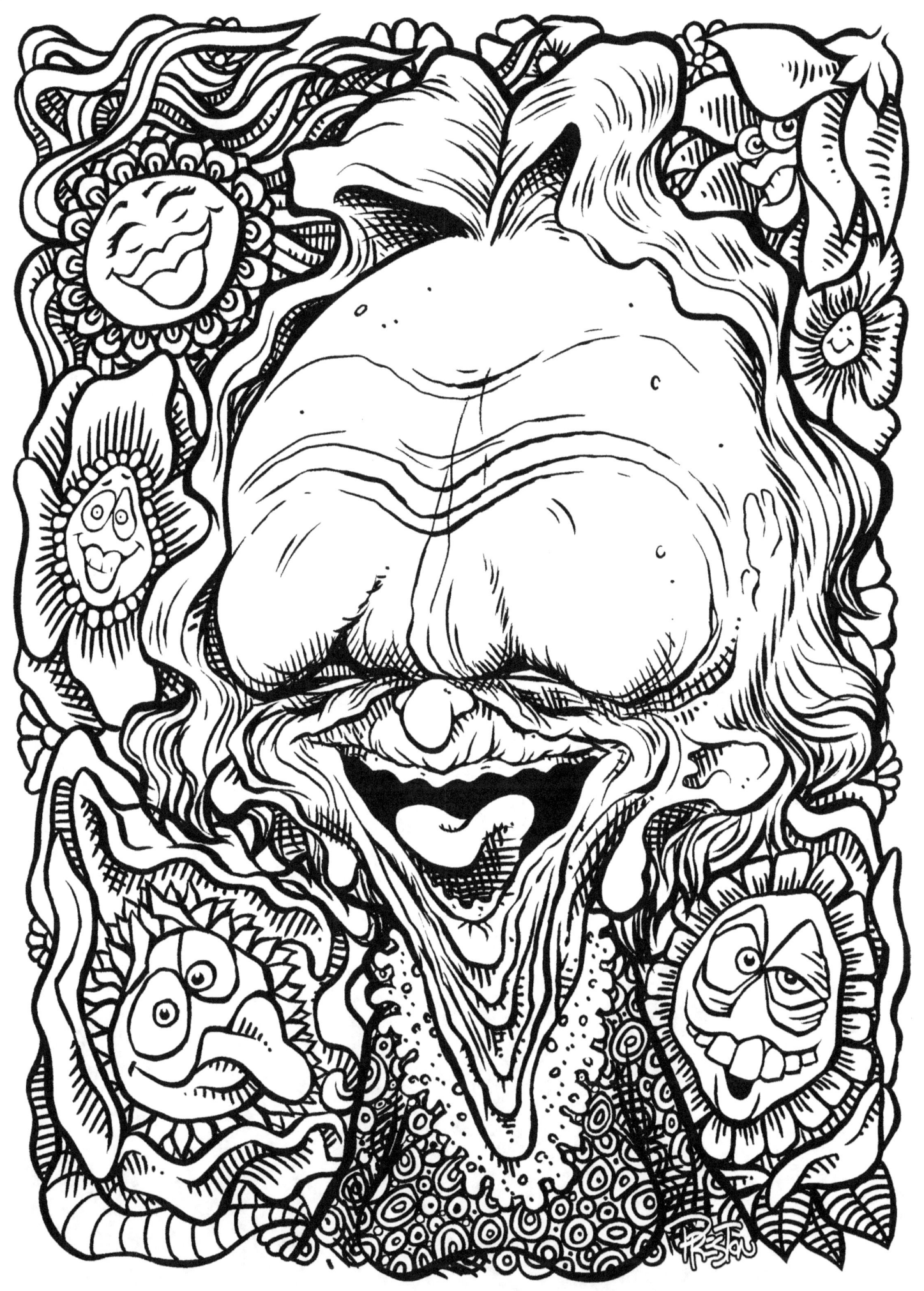

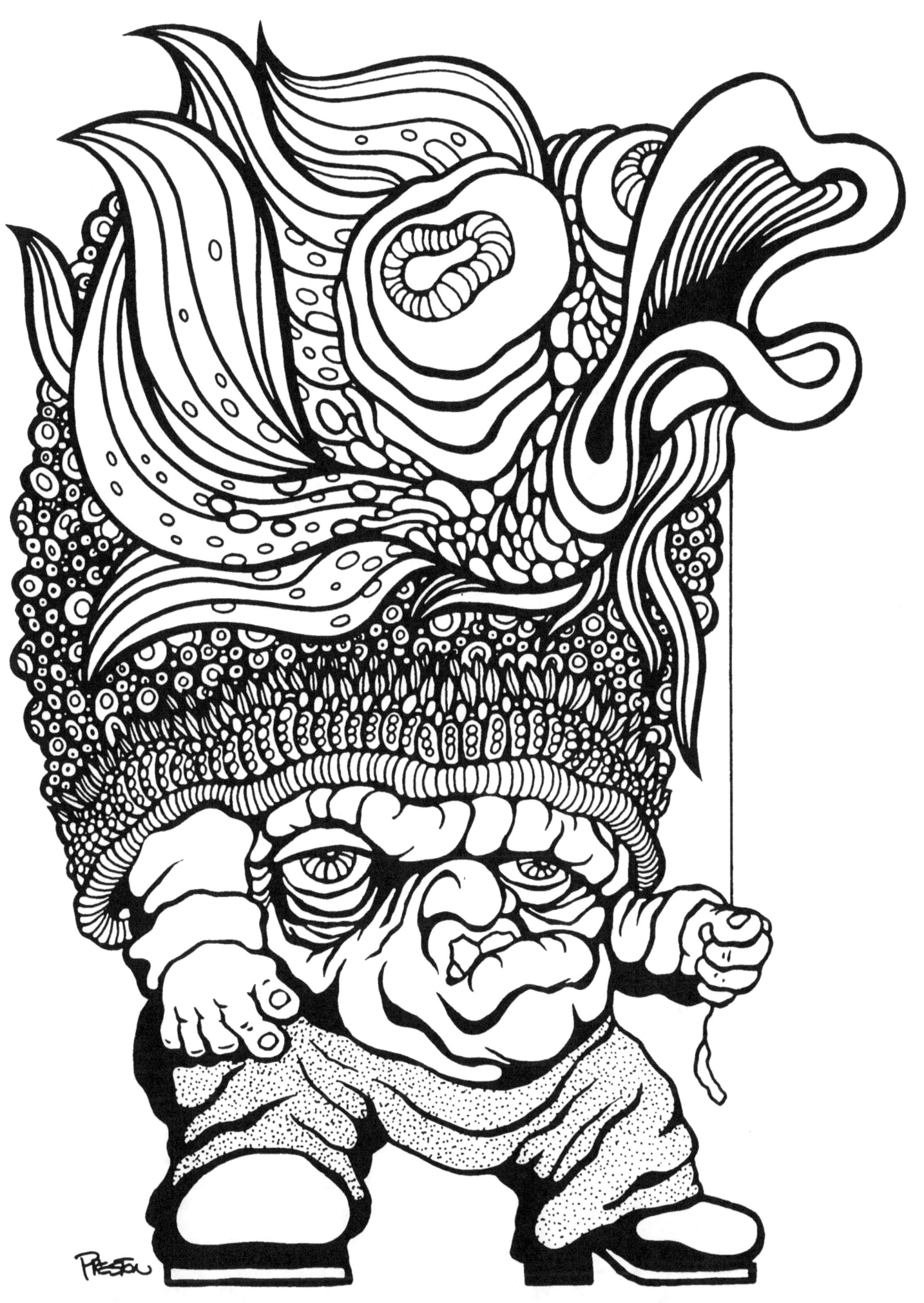

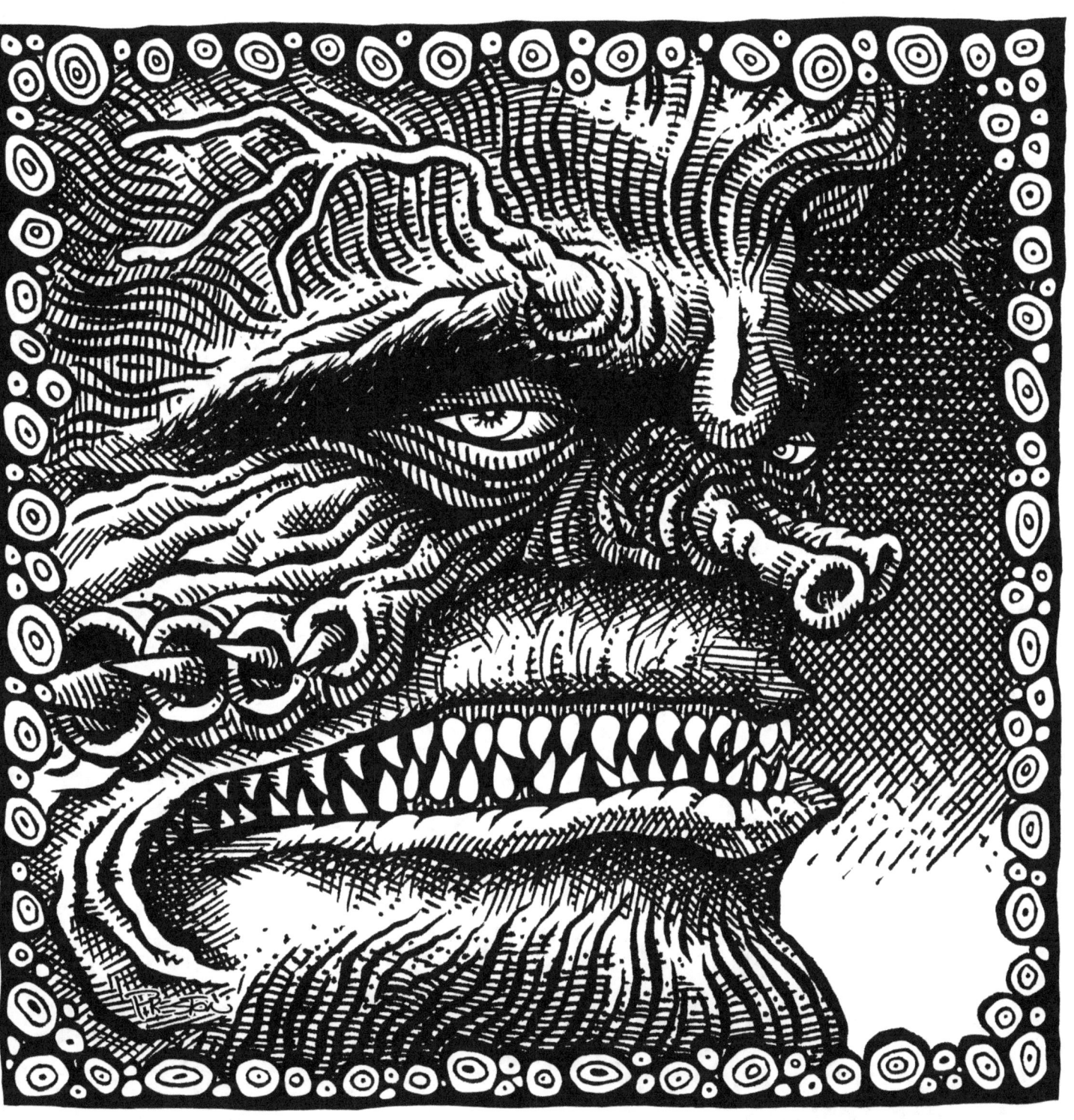

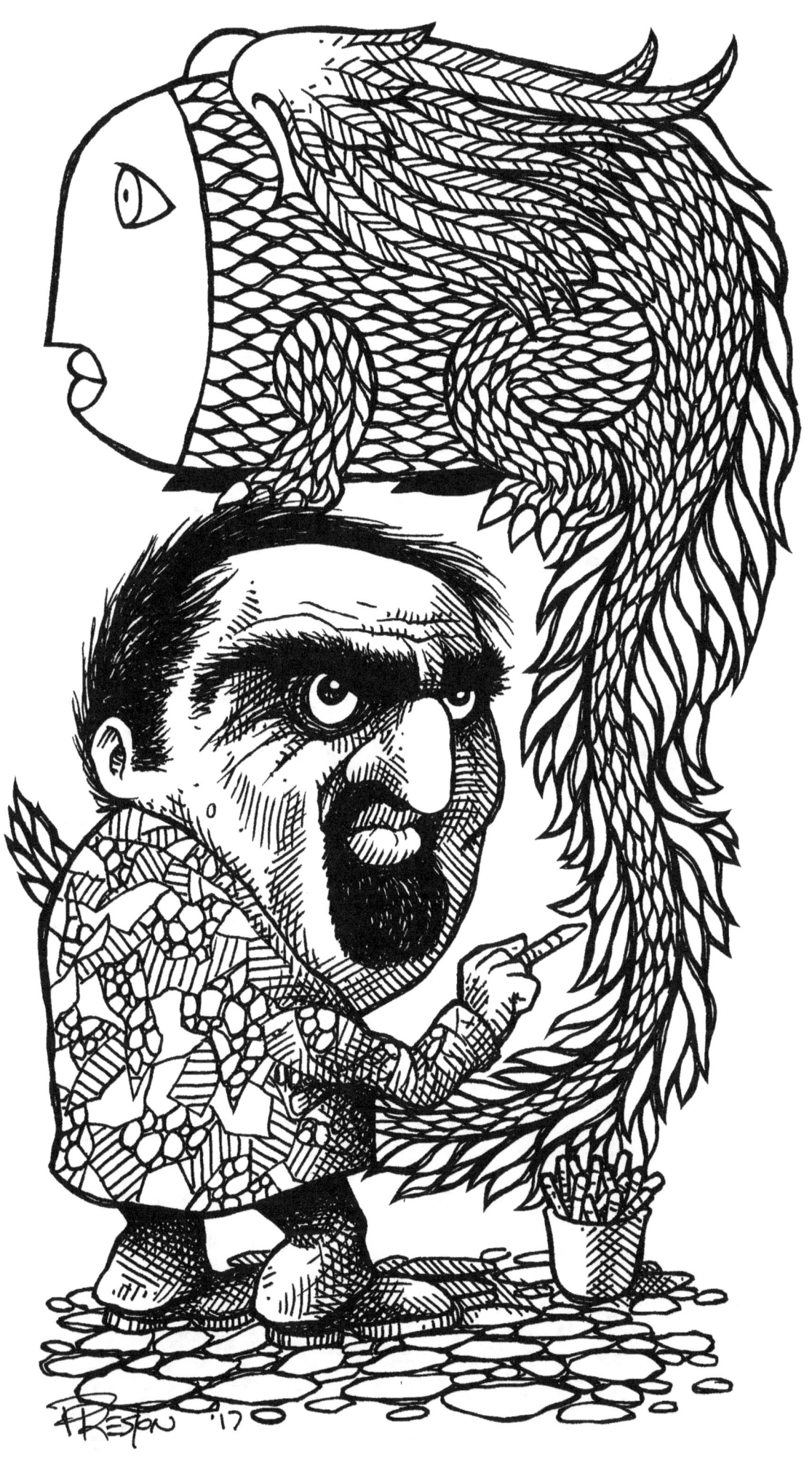

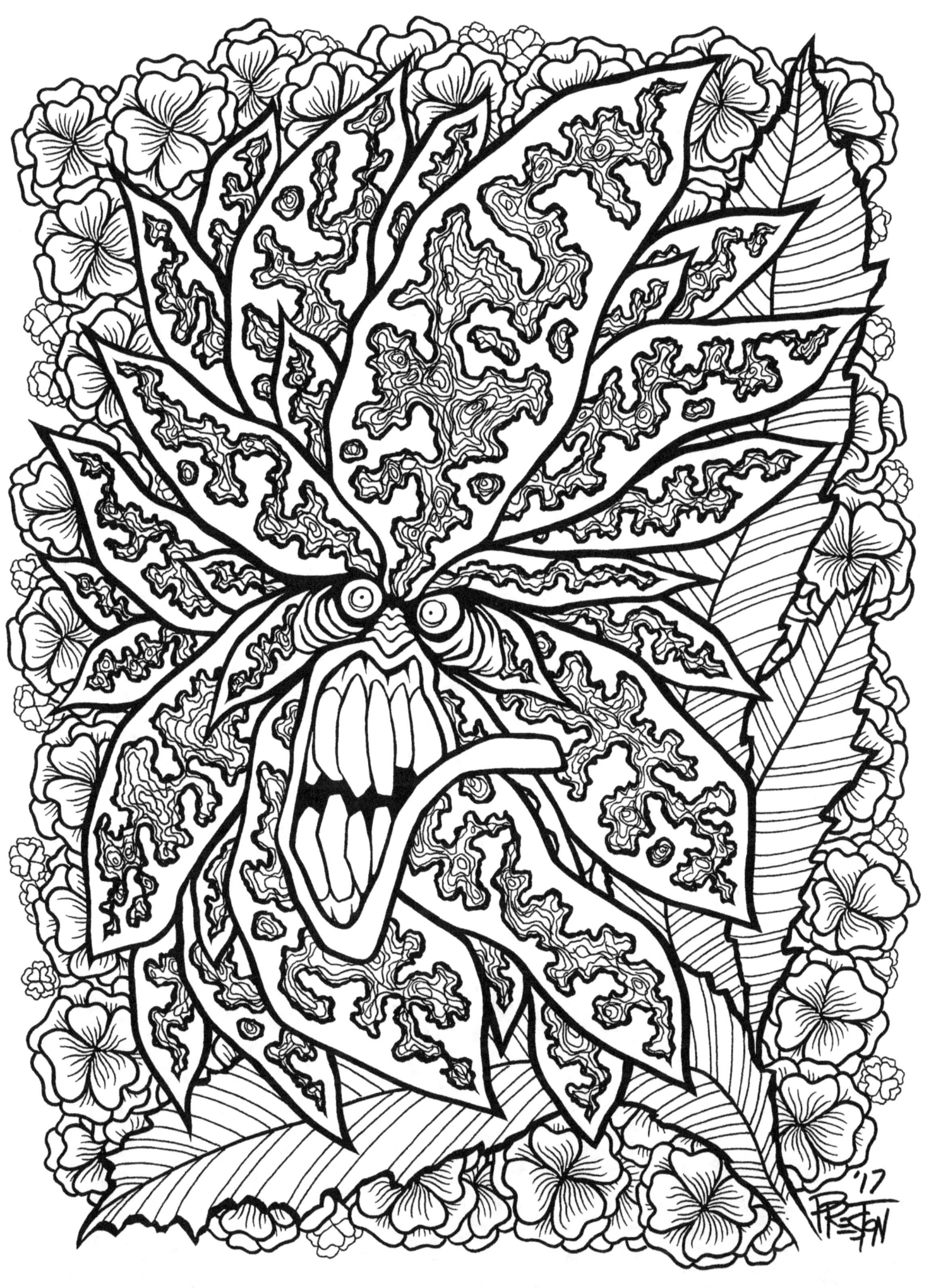

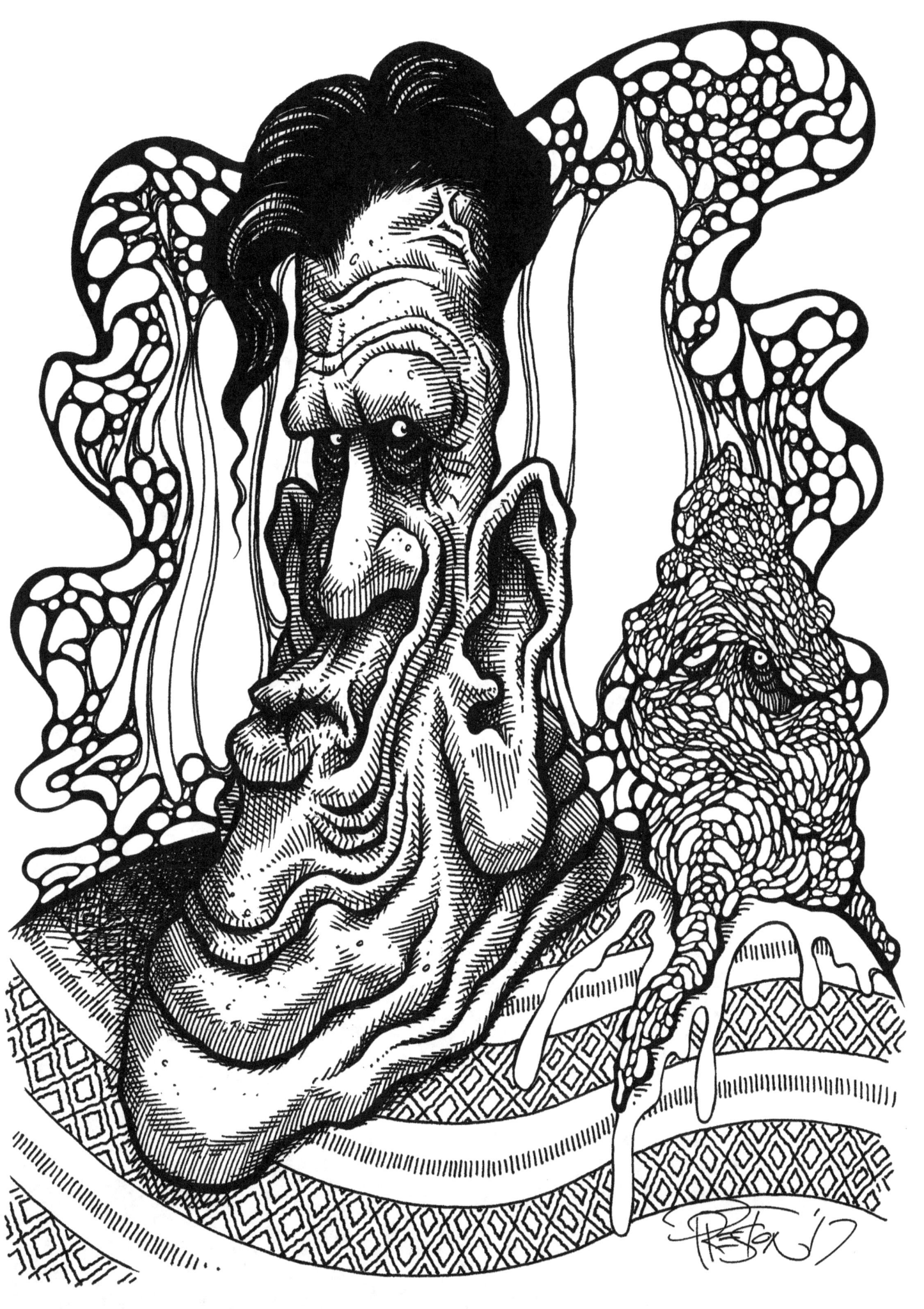

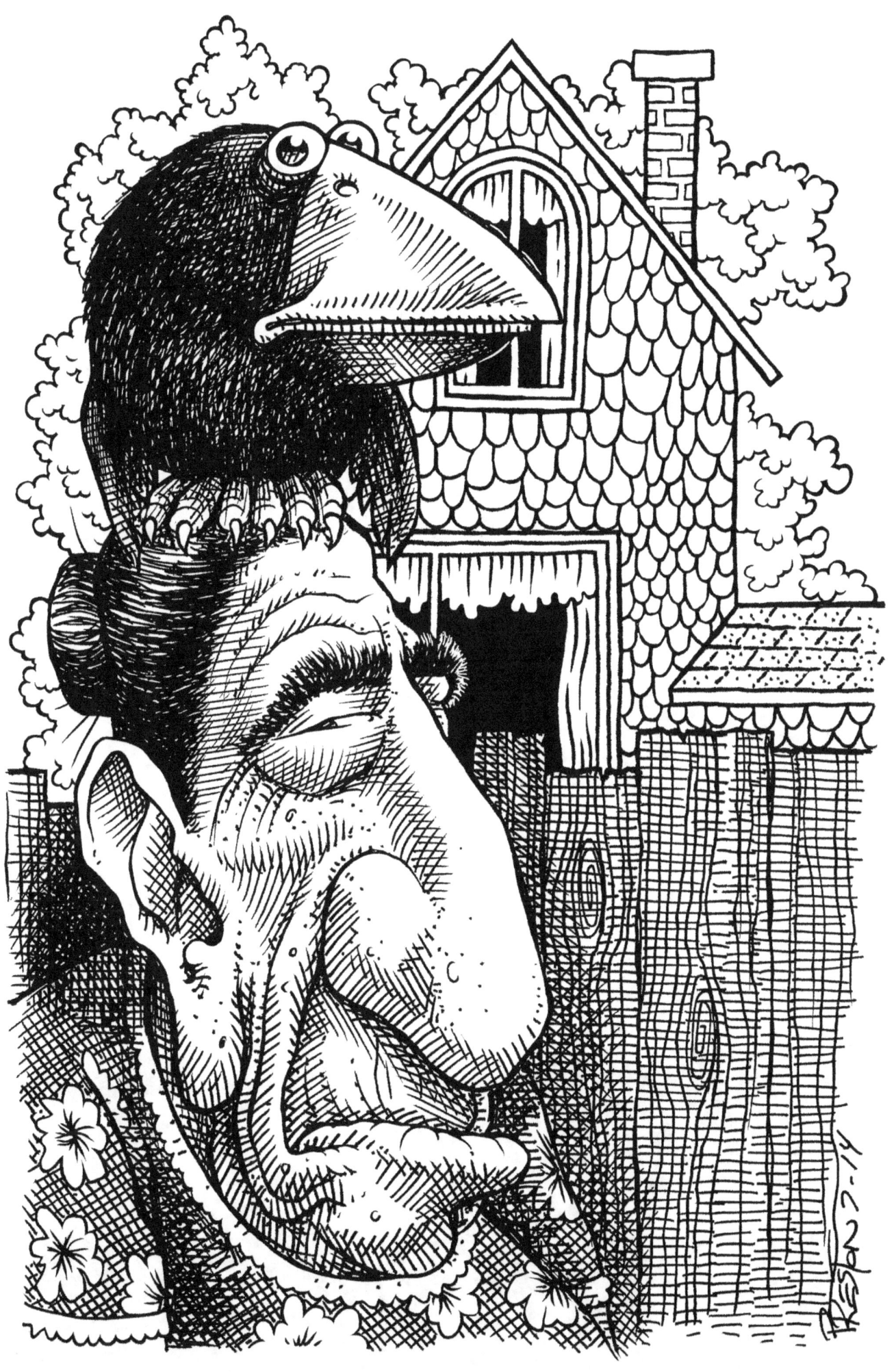

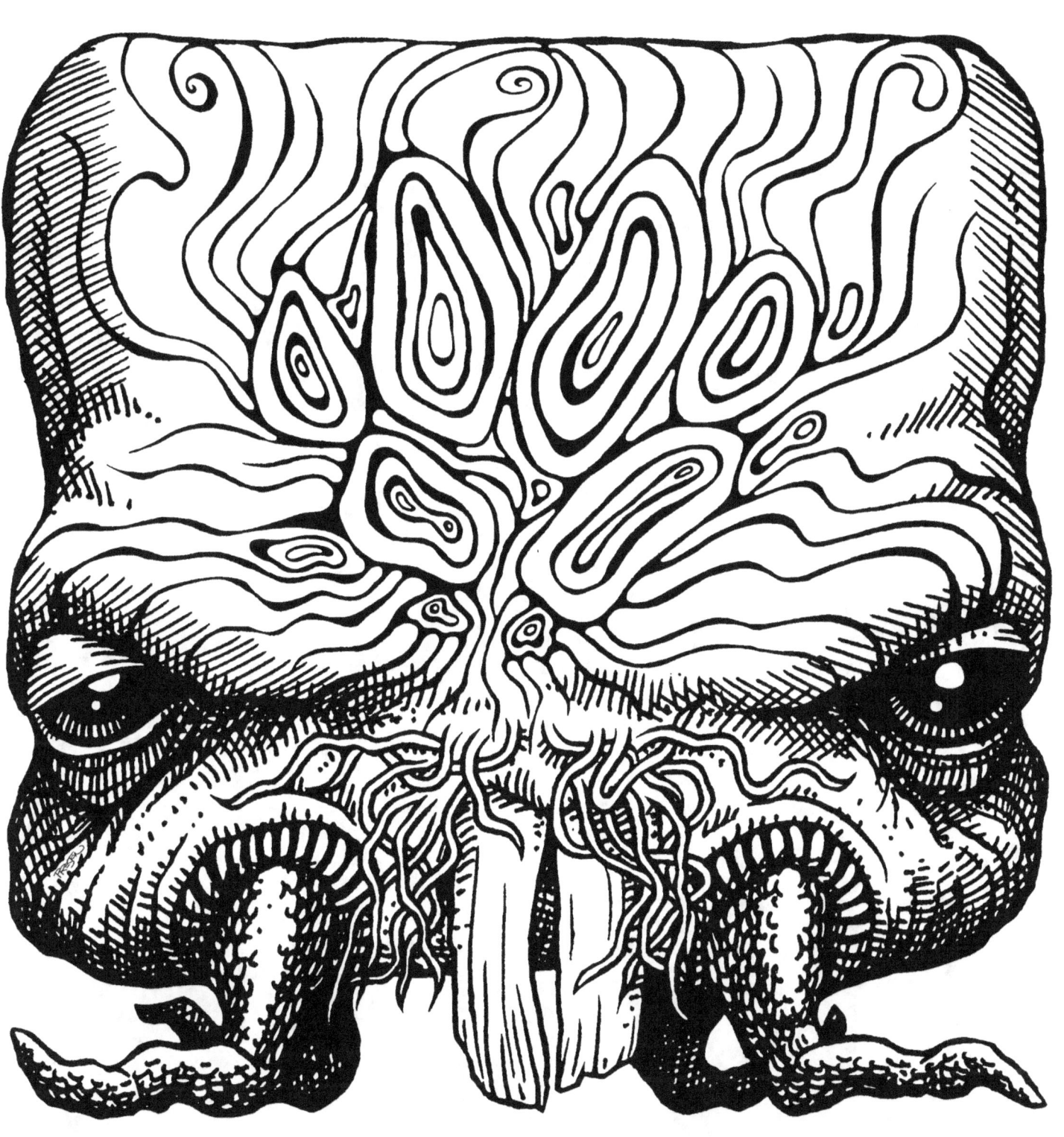

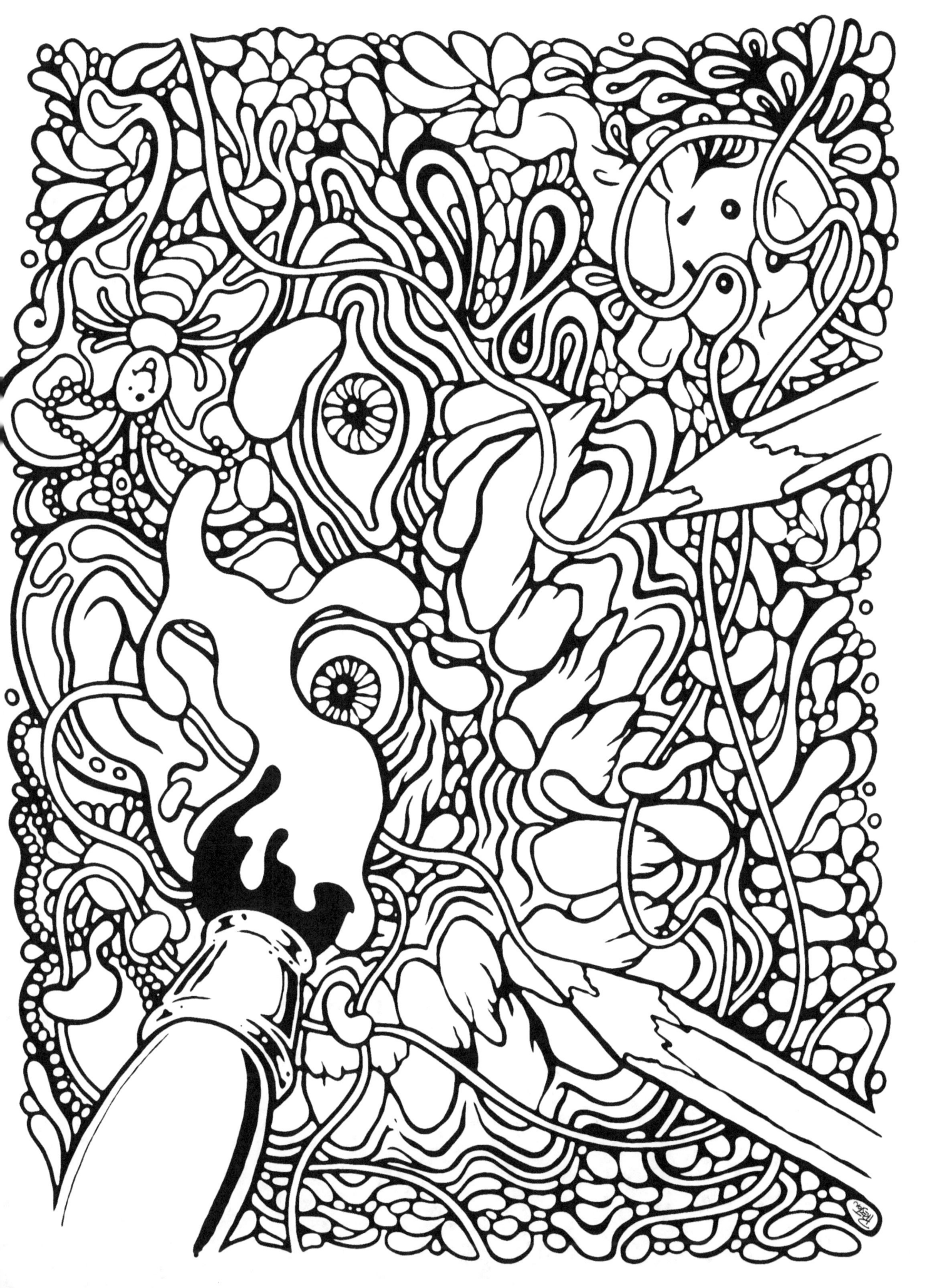

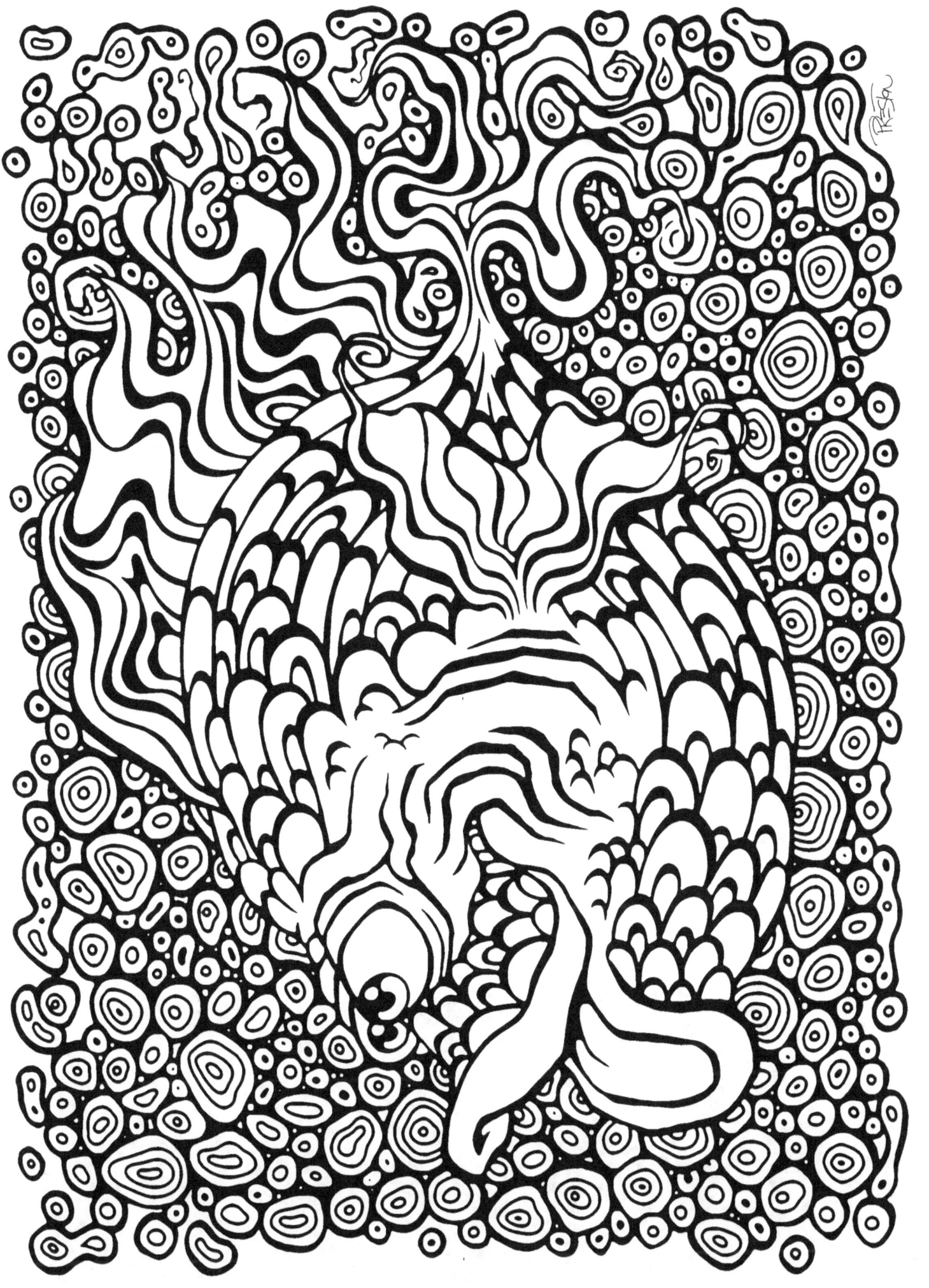

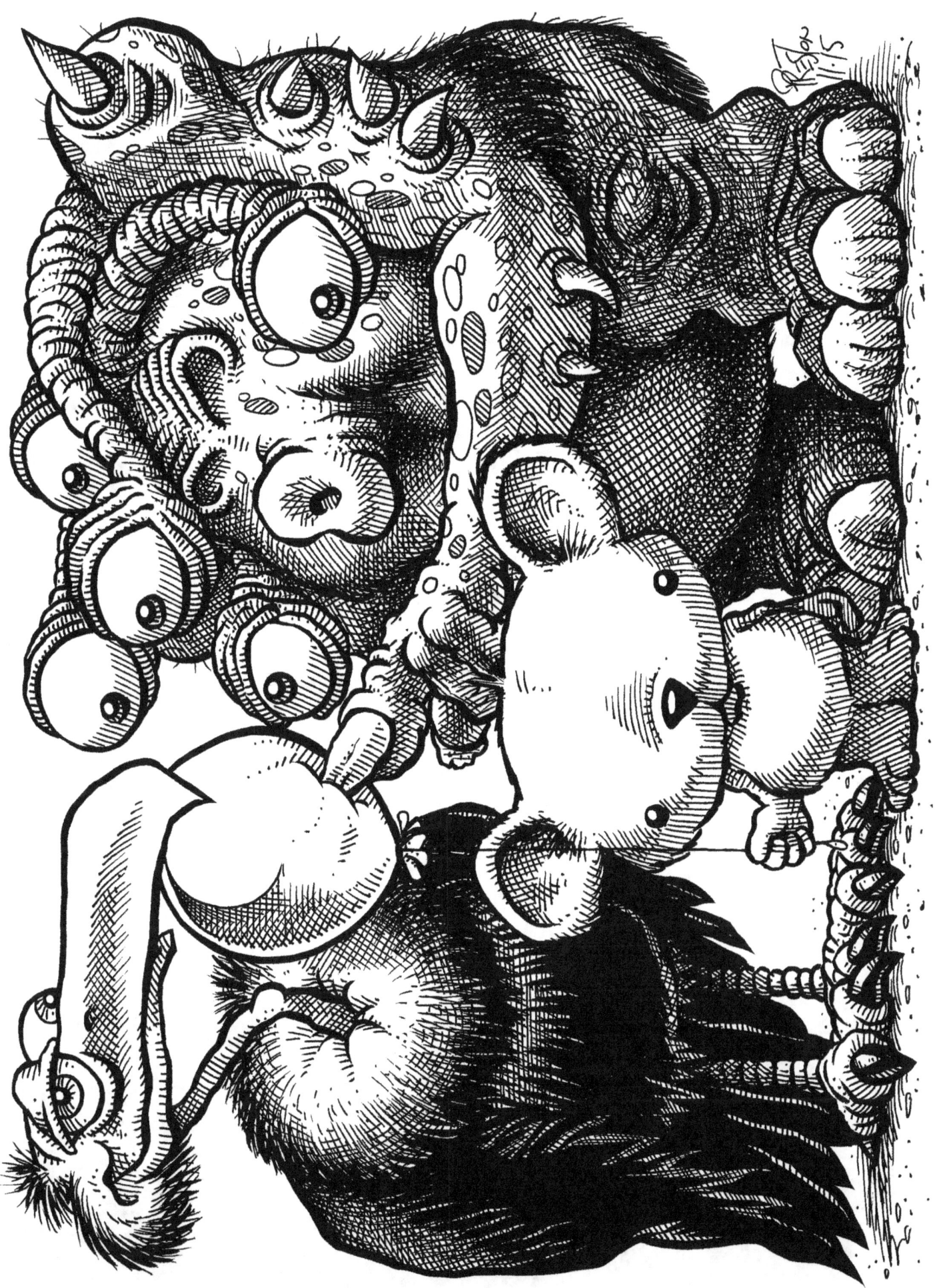

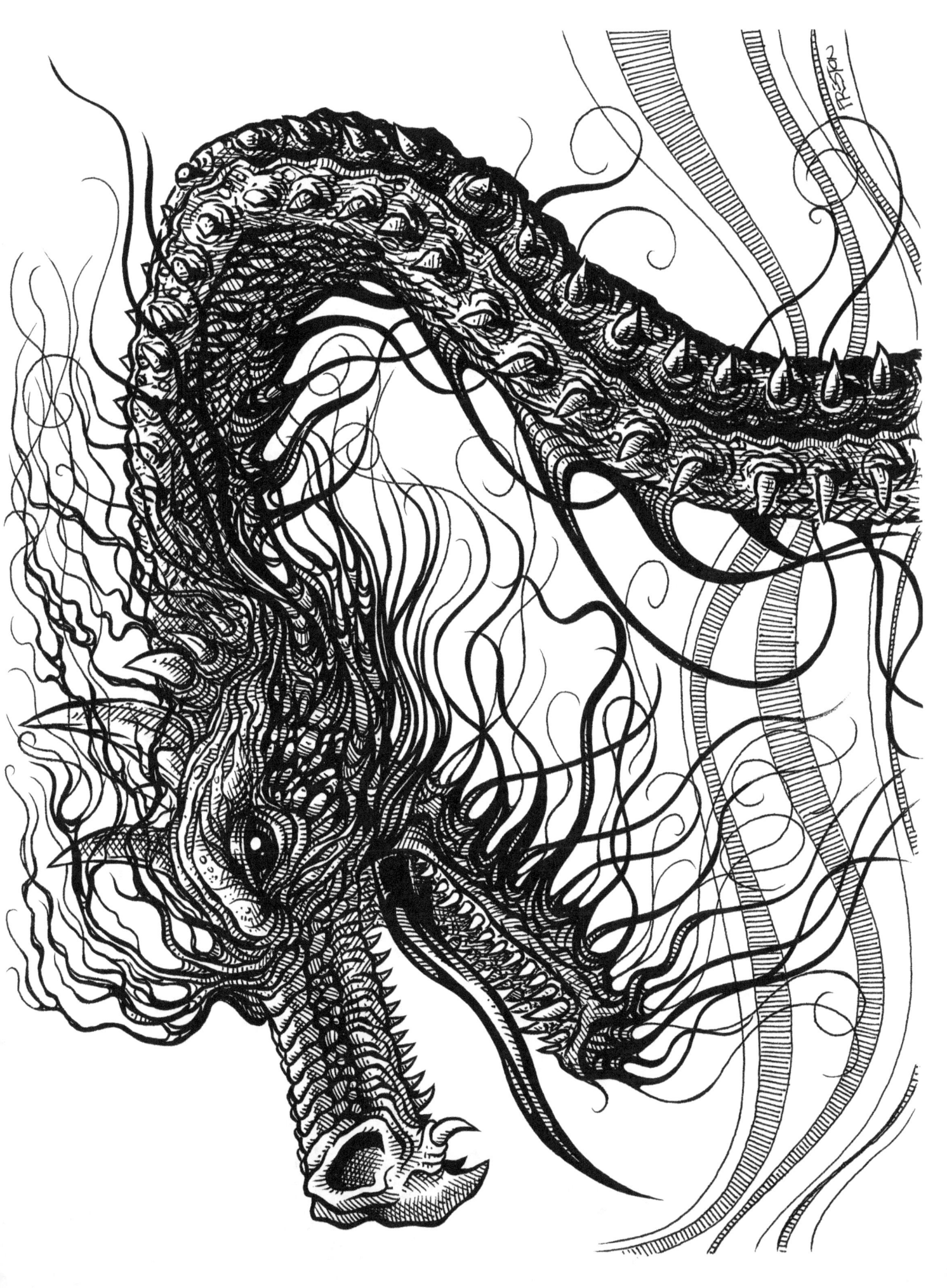

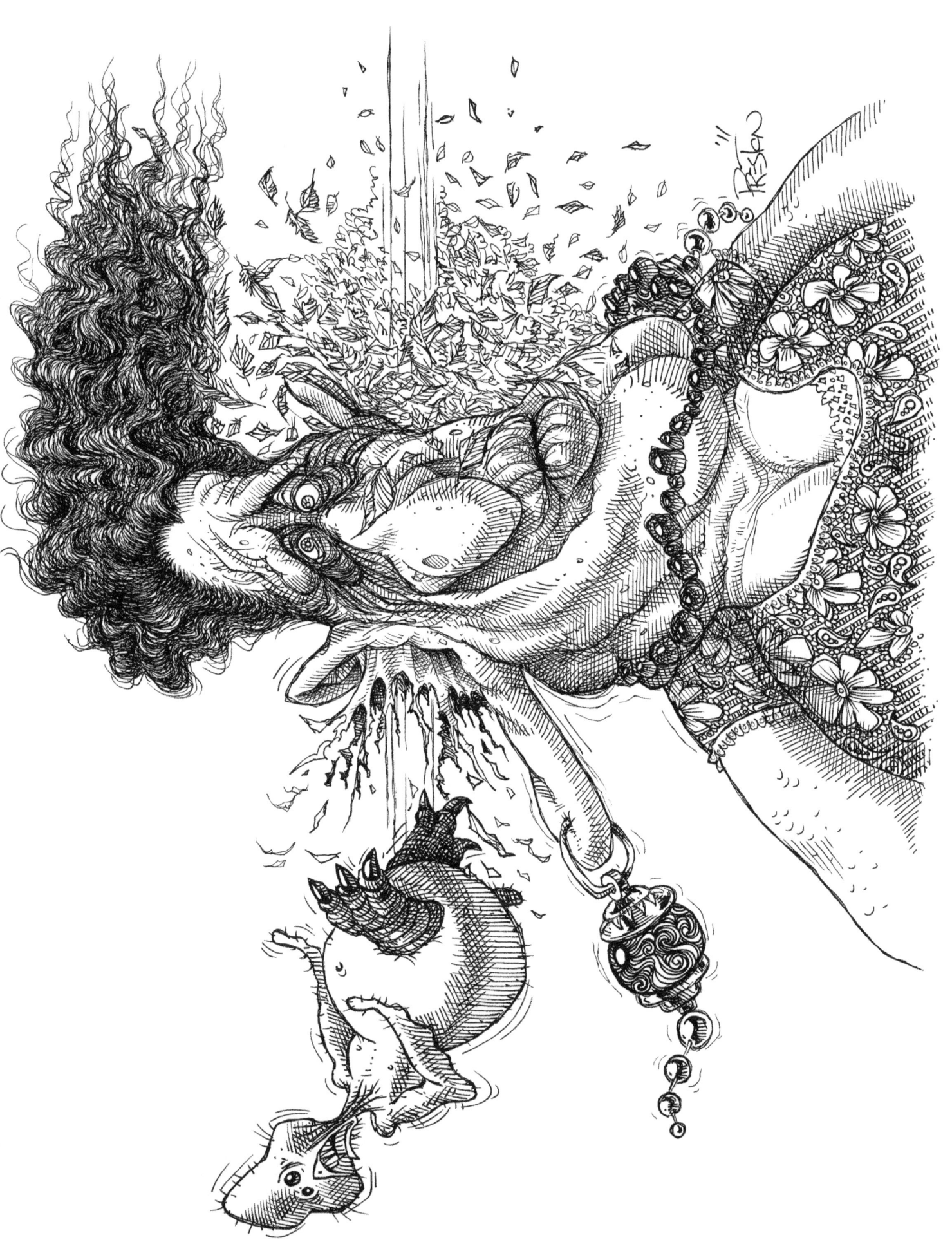

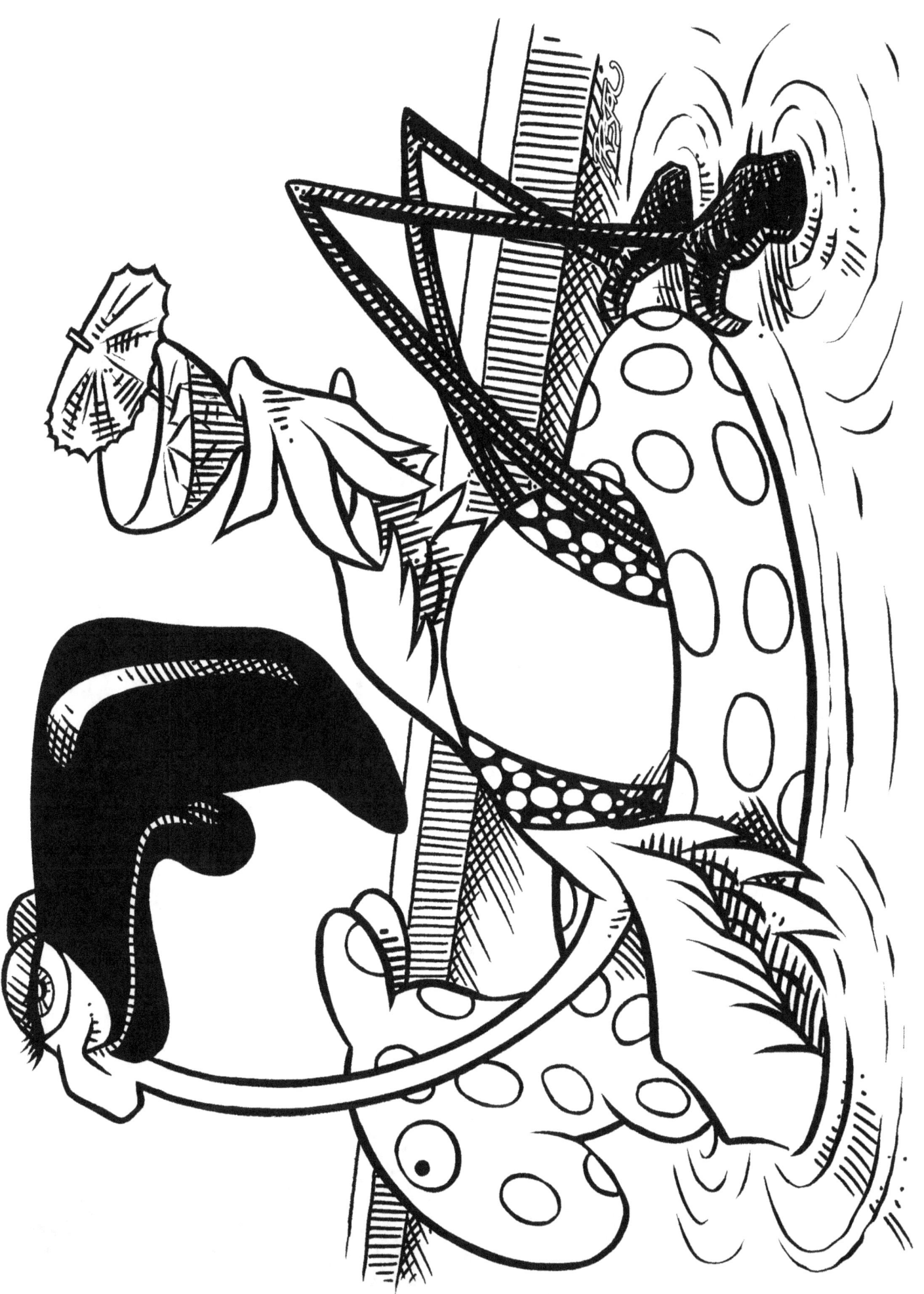

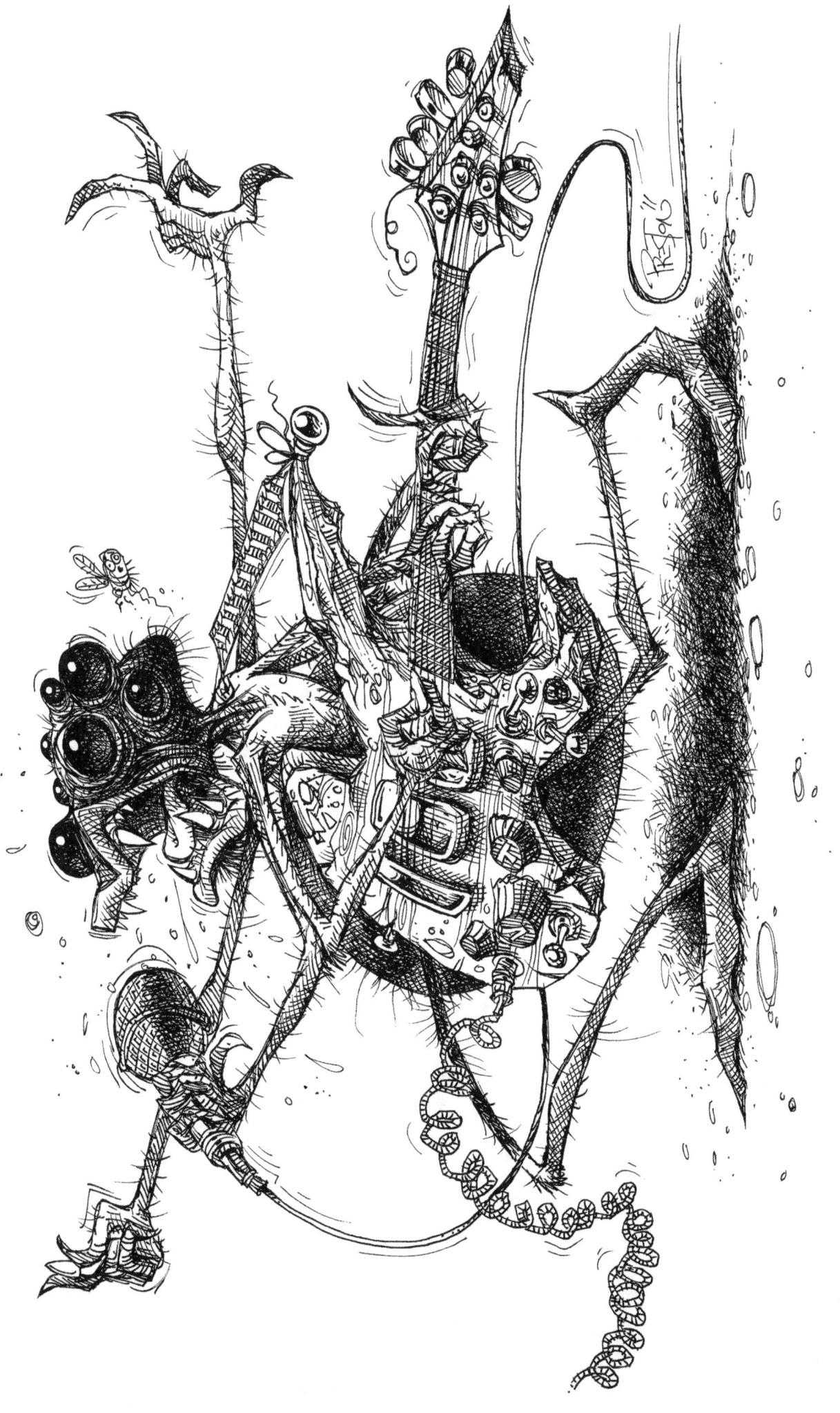

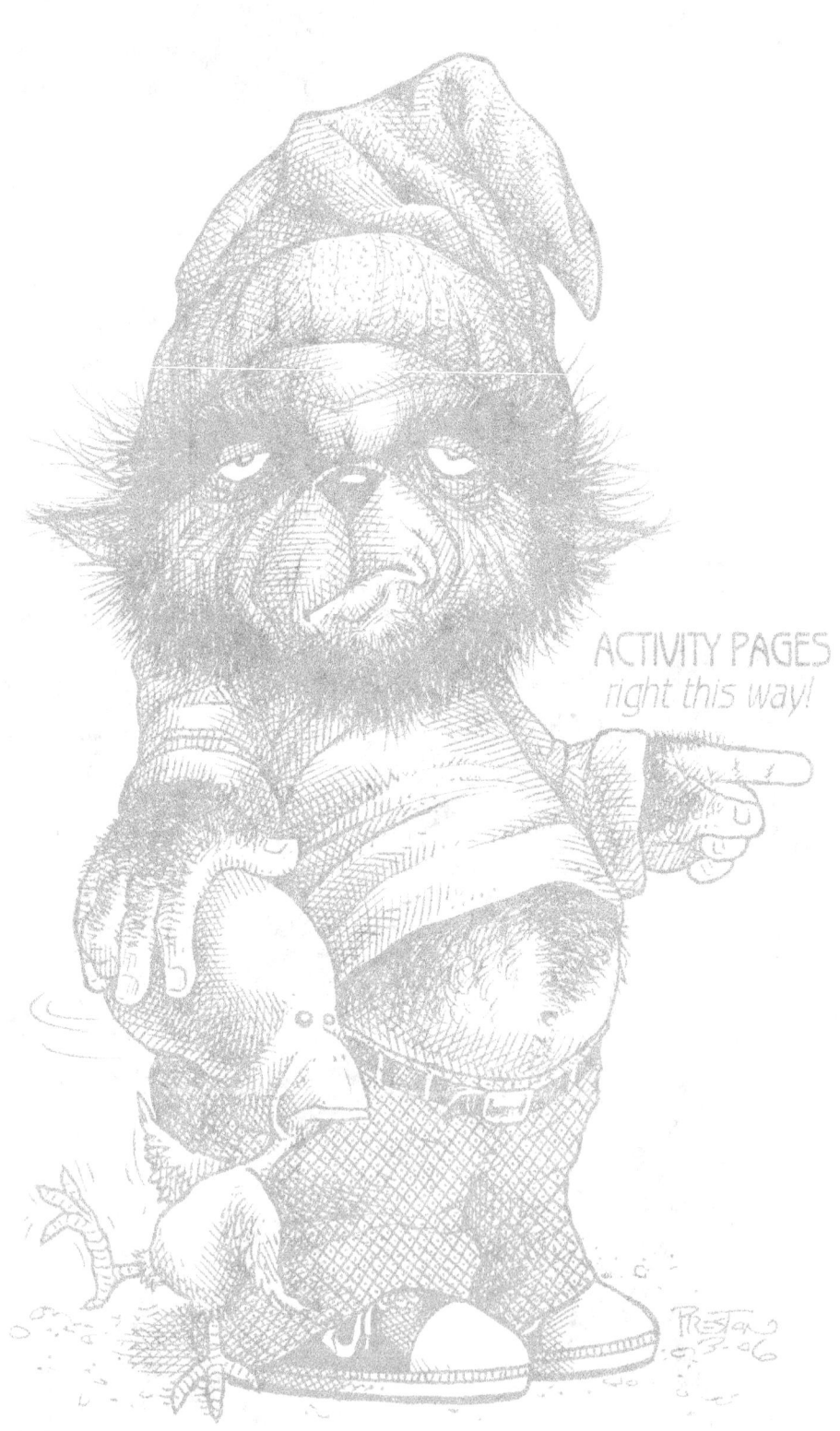

FINISH THE DRAWINGS

Here's one to get you started... just darken the gray lines.
A black ballpoint pen will work best for these.
If you're using felt tipped pens, test them out first on the last page for bleed through.

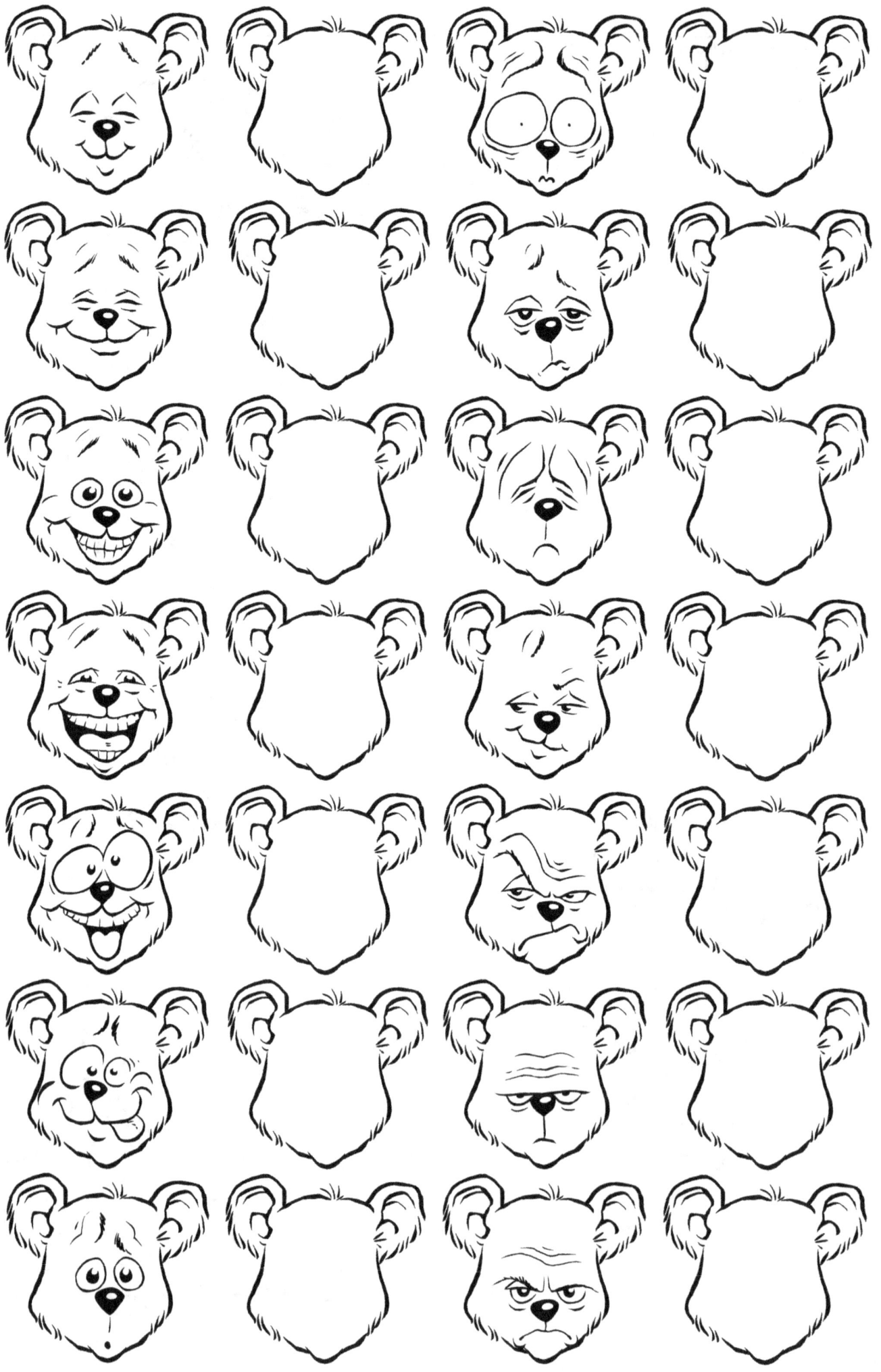

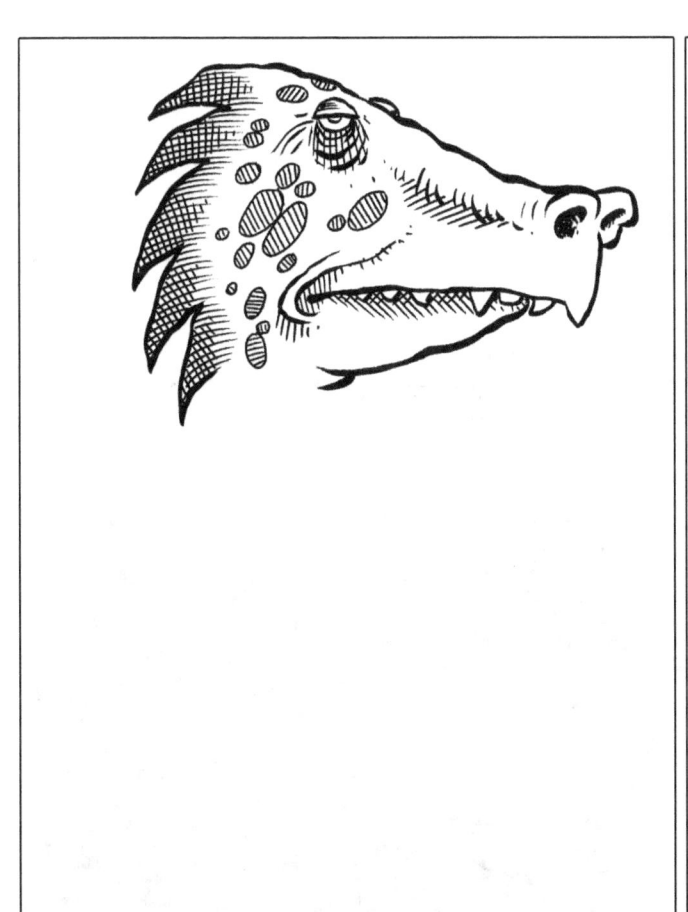
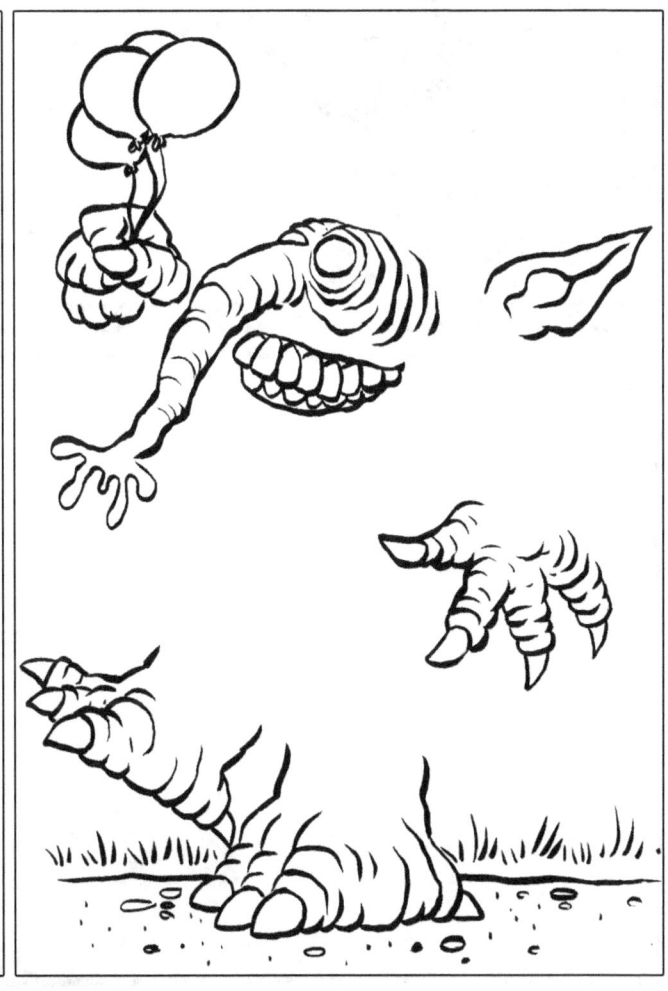

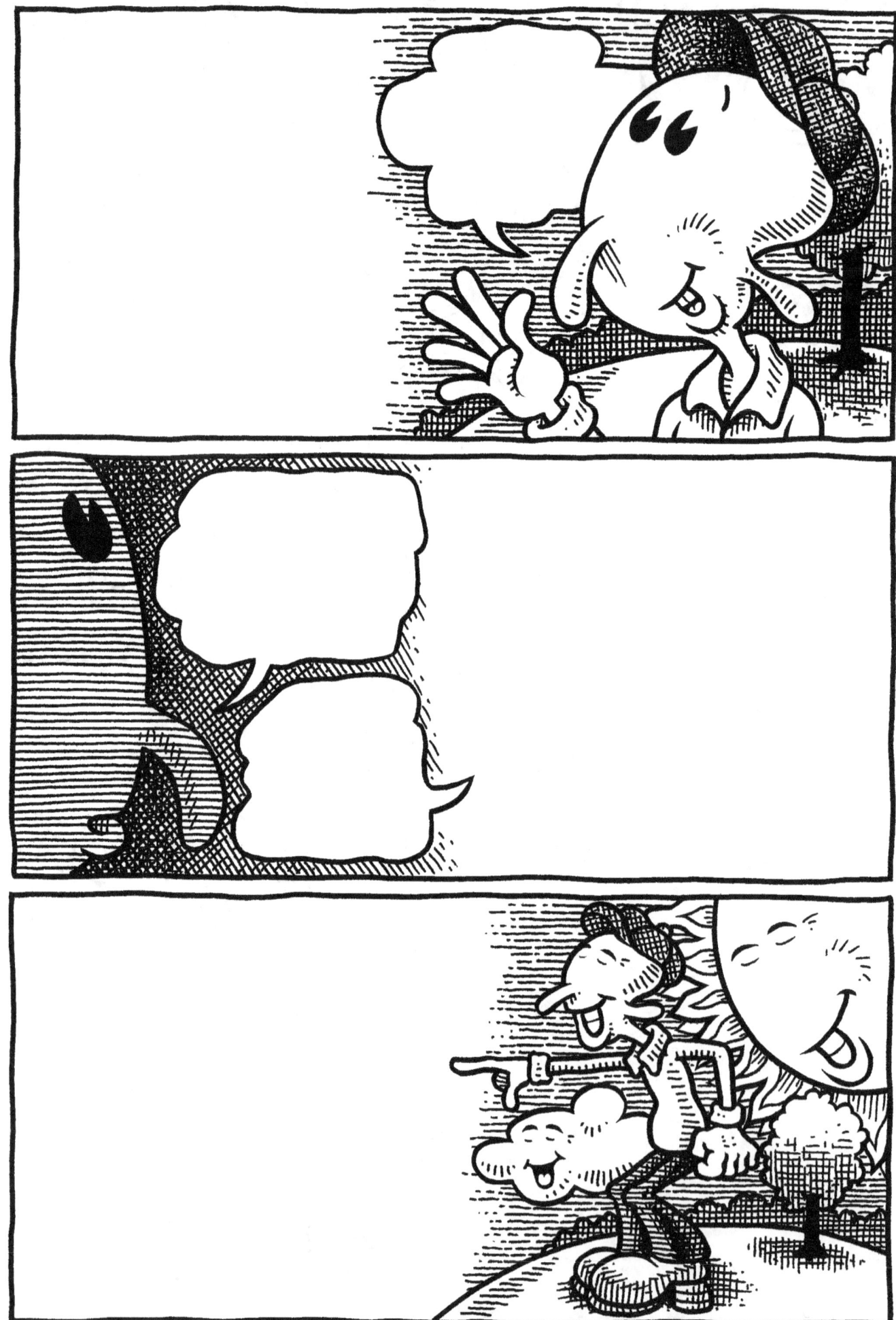

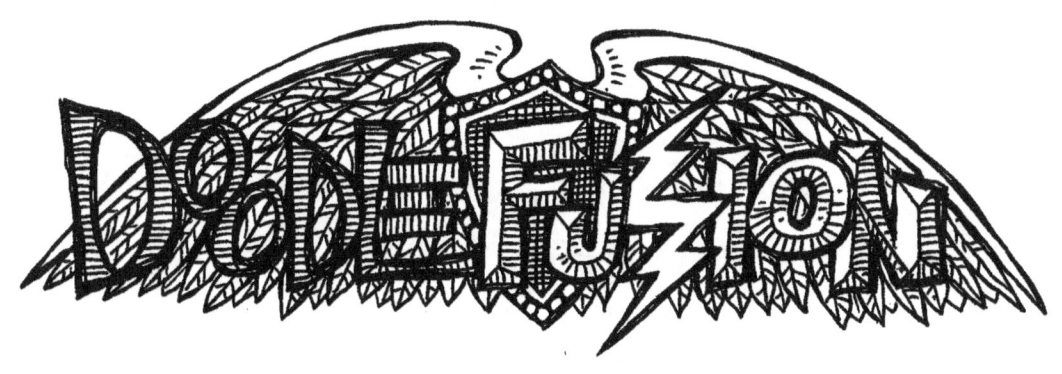

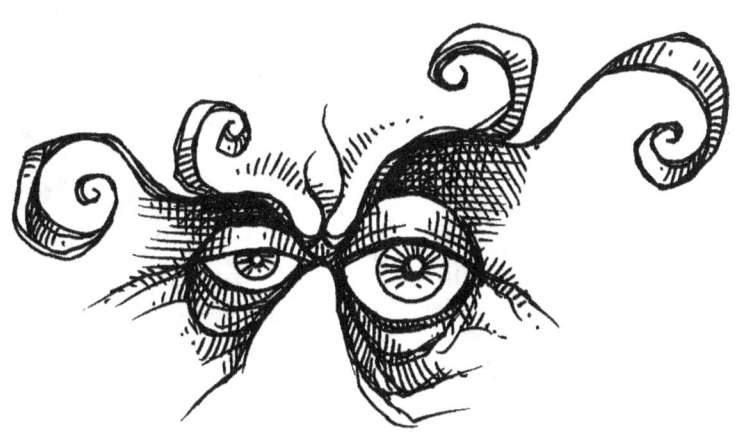

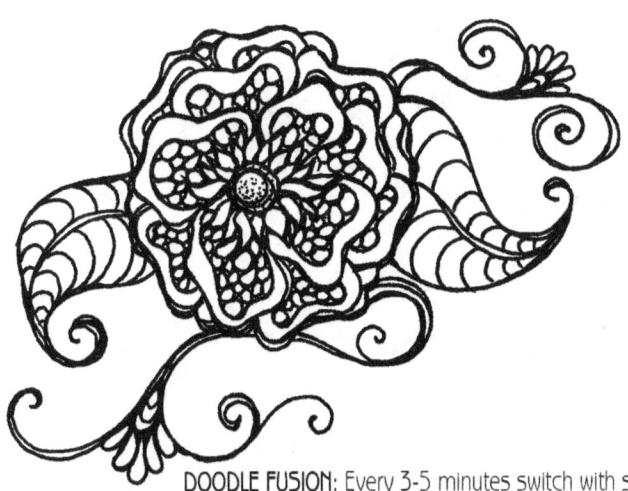

DOODLE FUSION: Every 3-5 minutes switch with someone to add doodles until everything flows together. Here's 2 to begin with.

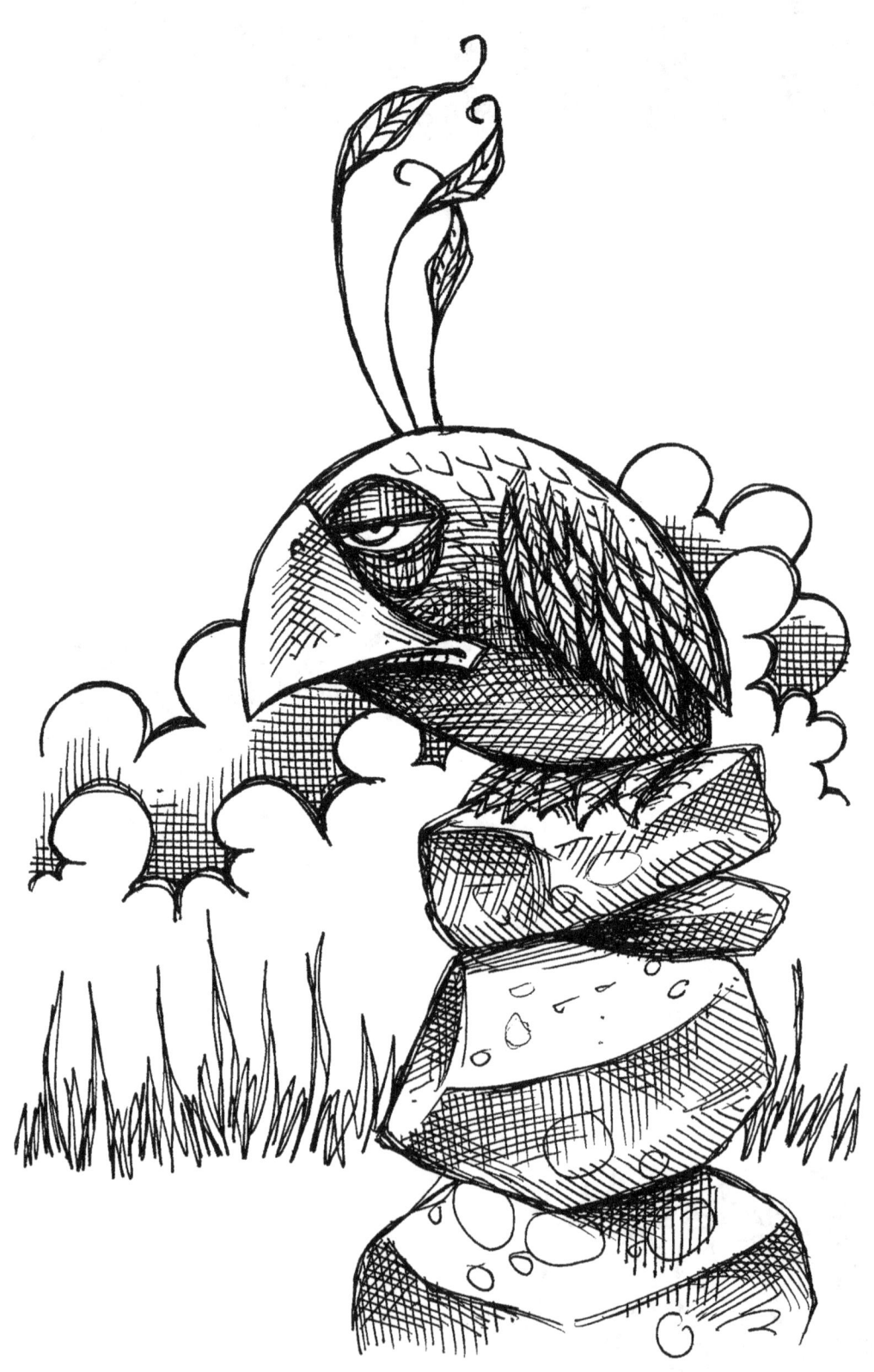

www.ingramcontent.com/pod-product-compliance
Lightning Source LLC
Chambersburg PA
CBHW080951170526
45158CB00008B/2445